TURNER
IN THE NATIONAL GALLERY
OF SCOTLAND

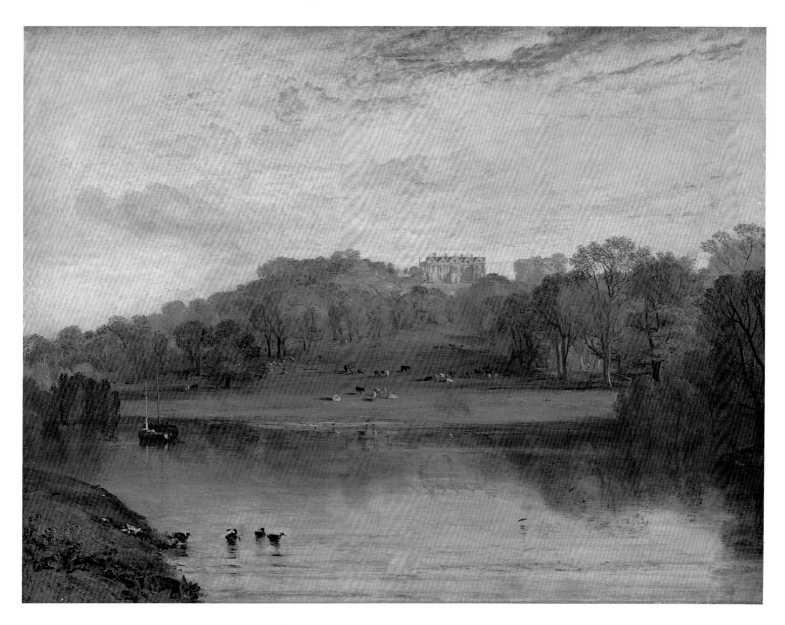

1 Somer-Hill, near Tunbridge, the Seat of W. F. Woodgate, Esq.

A COMPLETE

CATALOGUE OF WORKS BY

TURNER

IN THE NATIONAL GALLERY

OF SCOTLAND

MUNGO CAMPBELL

NATIONAL GALLERIES OF SCOTLAND

PUBLISHED BY THE
TRUSTEES OF THE NATIONAL GALLERIES OF SCOTLAND
ISBN 0 903598 31 0

©

FUNDED BY THE PATRONS OF THE NATIONAL GALLERIES OF SCOTLAND
IN ASSOCIATION WITH THE ROYAL BANK OF SCOTLAND

DESIGNED AND TYPESET IN BELL AND BASKERVILLE BY DALRYMPLE
PRINTED BY BALDING + MANSELL PLC
WISBECH

REPRINTED 1999
BY BAS PRINTERS LIMITED
OVER WALLOP, HAMPSHIRE

FOREWORD

OVER ONE HUNDRED AND FORTY YEARS after his death, Turner's reputation as perhaps the greatest of all British painters remains as strong as ever. The popularity of the Turner watercolour exhibition shown at the National Gallery of Scotland every January remains equally undiminished, over ninety years after Henry Vaughan bequeathed a group of thirty-eight of the artist's watercolours to Edinburgh. Since 1900 the Gallery's Turner collection has continued to grow, by gift, by bequest and by purchase. This new publication offers, for the first time, a catalogue of the whole of the permanent collection of Turner's works, including the prints for which many of his drawings were made. In addition to the well known watercolours of the Vaughan Bequest and the vignette *Illustrations to the Poetical Works of Thomas Campbell*, several drawings, such as the newly acquired *Bell Rock Lighthouse* and *Mount Snowdon* have not previously appeared in the recent literature on Turner.

The outright gift of the fine *Snowdon* watercolour was a spectacular and very recent example of generosity. The collection however must not be allowed to stop here. We should like, benefactors willing, to put together a complete set of engravings after our watercolours, to increase greatly our tiny holding of Scottish subjects and to acquire judiciously a few appropriate oils.

The publication of this catalogue would not have been possible without funding by the Patrons of the National Galleries of Scotland, in association with The Royal Bank of Scotland. We are particularly indebted to both benefactors for their generous support. Finally I am indebted to my colleague Mungo Campbell for compiling this catalogue in a very short time with his customary skill. He was greatly assisted in his task by Margaret Kelly and Valerie Hunter. Any new catalogue of the Gallery's Turners must acknowledge its debt to John Dick's pioneering work on the collection.

TIMOTHY CLIFFORD
Director · National Galleries of Scotland

J. M. W. TURNER
A BIOGRAPHICAL INTRODUCTION

JOSEPH MALLORD WILLIAM TURNER was born in London on 23 April 1775, at 21 Maiden Lane, Covent Garden, the son of a barber and wig-maker. By the age of twelve he had signed and dated his first drawings and in 1789 he was admitted as a student to the Royal Academy schools. At around this date he also studied with the architectural draughtsman, Thomas Malton. In 1790 Turner exhibited his first watercolour at the Royal Academy exhibition, a view of the Archbishop's Palace at Lambeth. His sketching tours, both to Britain and the Continent, started in the early 1790s. It was at about this time too that he first met Dr. Monro.

Thomas Monro (1759–1833) succeeded his father as physician at the Bethlem Hospital in London in 1792. An accomplished amateur draughtsman, he also inherited his father's collections and, after moving to Adelphi Terrace in 1793, started to hold an evening 'Academy'. There young watercolour painters would copy works from his collection, colour each other's outline drawings and practise other exercises of topographical draughtsmanship.

Among the artists who attended the 'Academy' during its existence were John Sell Cotman, Peter De Wint and John Varley. Turner worked there from 1794–1797, along with Thomas Girtin. Girtin's 'Monro School' work is especially close to Turner's. His early death, in 1802, put an end to a career which promised much. Turner's undoubted respect for Girtin's abilities is summed up in the apocryphal remark that 'Had Tom Girtin lived, I should have starved'. Monro's 'students' were given supper and paid for their work. According to Joseph Farington, the artist and great diarist of artistic life in Britain at the period, Turner, for example, received 3s 6d per night.

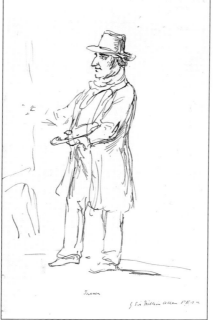

J. M. W. Turner by Sir William Allan
Pen and ink on paper, 26.6 × 19.9 cm
Scottish National Portrait Gallery

Dr. Monro was particularly interested in psychiatric medicine. When, in 1794, the watercolour painter John Robert Cozens began to suffer from increasingly serious mental illness, Monro took him into his care. During this period he built up a substantial collection of the artist's work. Cozens provided pencil outlines for the 'students' to colour as well as drawings to copy.

Cozens was undoubtedly a powerful influence on Turner, who gradually abandoned a purely topographical rendering of landscape, with its emphasis on descriptive outline drawing, developing instead the broader, more analytical and atmospheric watercolour style which began to appear in the 1790s. Turner's tours to the mountains of North Wales in 1798 and 1799 had a profound effect on the development of this new style. The Gallery's newly acquired *Mount Snowdon* is typical of the brooding and mysterious mountain views of these years.

It was at this time that Turner's fascination with the 'Sublime' began to manifest itself in his work. In 1757 Edmund Burke had published his *Philosophical Enquiry into the Origin of our Ideas of the Sublime and the Beautiful*. For Turner, as for many artists and writers at the end of the eighteenth century, the vastness and violence of nature inspired an awe and indeed a terror which was described as the experience of the 'Sublime'. It was the opportunity to express these emotions through landscape painting which attracted Turner repeatedly to the mountains of Britain and the Continent, and to paint the savage elemental forces seen in avalanches, storms and mountainous seas.

In 1796 Turner exhibited his first oil painting, *Fishermen at Sea*, at the Royal Academy (now Tate Gallery, reg. 1585). The subject of the painting is a foretaste of the fascination with the sea and ships which

was to be reflected in his work throughout his career. During the late 1790s Turner's painting developed rapidly as his vision of the landscape matured and his technical powers, both on canvas and on paper became apparent to an ever wider public. Success at the Royal Academy was equally rapid. He was elected an Associate in 1798 and a full member in 1802, becoming Professor of Perspective in 1807. Conscious, from the very start of his career, that he needed a place where the public could examine his pictures, at all times and away from the tumult of exhibitions, Turner opened his own gallery at Harley Street in April 1804.

The headlong rush by British artists and travellers to the Continent, following the Peace of Amiens in 1802, saw Turner make his first trip abroad, to France and Switzerland. It would be another fifteen years before the opportunity arose again. Instead, tours round the British Isles provided Turner with his material, encouraged by patrons such as Lord Egremont and Walter Fawkes, at whose houses at Petworth and Farnley he often stayed. Our watercolour of *Caley Hall*, in Yorkshire, was owned by Fawkes. Turner visited Farnley almost every year from 1810 until 1824.

In 1811 Turner was commissioned by W. B. Cooke to provide illustrations for his *Picturesque Views of the Southern Coast*. He had already embarked on his own visual manifesto of his art, the *Liber Studiorum*, of which the first volume of prints appeared in 1807. The *Southern Coast* engravings marked a new departure however. For the rest of his career Turner was almost constantly working on the illustration of one publishing project or another. From the tremendous *Bell Rock Lighthouse* of 1819, commissioned as a frontispiece by Robert Stevenson, to the equally stormy invocation of the Sublime at the wind-swept Cape of Good Hope, in the tiny vignette for Thomas Campbell's *The Pleasures of Hope* published in 1837, Turner's career and his fame turned, as much as anything else, on his abilities to provide the coloured drawings which engravers could translate into black lines on white paper.

The early nineteenth century saw a considerable increase in the market for illustrated books. From the start of his career Turner had proved to have a supreme understanding of the needs of the engraver, initially producing work for full-scale copperplate illustrations for guide books and topographies such as the *Southern Coast*

and Sir Walter Scott's *Provincial Antiquities of Scotland*.

As the print runs of illustrated books grew, the short life span of the copper plates, from which the images in these publications were printed, increasingly became a problem. Steel wore down less quickly but being harder was more difficult and more expensive to work. The small vignetted steel engraving (though still costly) became an economic proposition for a publisher if he could offset against his capital outlay the potential attraction of Turner's name and large volume sales. In 1831 Sir Walter Scott was told by his publisher Robert Cadell that 'with Mr Turner's pencil I shall insure the sale of 8,000 of the poetry–without, not 3,000'. The 1820s and 1830s saw, under Turner's influence above all, a rapid development and refinement of steel engraving.

Most of Turner's continental tours were made with specific publishing projects in mind. After the end of the Napoleonic Wars, Europe opened up to travellers as never before and the middle-class appetite for illustrated guides and topographical views of continental scenery offered both artists and publishers a ready market. In 1817, Turner himself had been able to visit the Continent for the first time in fifteen years. He travelled through the Rhineland, making hundreds of the rapid pencil drawings from which he later worked up his finished watercolours. Our drawing of the *Rhine at Neuweid* is taken from one of these studies. In 1819 he made his first trip to Italy, visiting Turin, Como, Venice, Rome and Naples, returning via Florence.

The mid-1820s saw Turner's reputation as an illustrative draughtsman reach its peak. The first plates of the mezzotint series *The Rivers of England* were published in 1823. The *Ports of England* mezzotints were issued in 1826, and in the same year he was commissioned by Charles Heath to produce a series of one hundred and twenty drawings for *Picturesque Views in England and Wales*. The project was to bankrupt Heath and pass through the hands of three other publishers before it was finally abandoned, the plates remaining in Turner's hands at the time of his death. The same year, 1826, Turner also started work on illustrations for Samuel Rogers' poem *Italy*. He had finished these by August 1828, when he set off for his second visit to Florence and Rome, where he spent that winter.

Turner had first come into contact with Sir Walter Scott's work in

1818, when he visited Scotland to gather material for plates to Sir Walter's *Provincial Antiquities of Scotland*. The relationship lasted until Scott's death in September 1832 and continued for several years after that through Robert Cadell's project to publish Scott's *Works*. By chance, in January 1830, Scott was sent a copy of Samuel Rogers' new edition of his poem, *Italy*. The union of Rogers' poetry and Turner's images, successful both aesthetically and financially, appealed to both writer and publisher who were seeking to repeat their recent success with the *Waverley Novels* (illustrated by artists such as Landseer, Martin, Stanfield and Bonington). By March, Turner had agreed to provide the illustrations for the complete edition of Scott's *Poetic Works*. It was this project which brought Turner to Scotland in 1831, staying at Abbotsford before moving on to Edinburgh and the Highlands. The two men were never close friends. Their mutual respect for each other's art however, skilfully nurtured by Cadell, produced remarkable results. A fine group of Scott illustrations is now in the collection.

The vignettes which Scott had seen for the illustrated edition of Rogers' *Italy*, had been a great success. They had provided the first opportunity for many, including the 13 year-old John Ruskin, to look at Turner's work. It was this book, Ruskin later claimed, to which he could attribute 'the entire direction of my life energies'. The book had not been popular on its first appearance in 1822 and its new-found success owed much to the integration achieved between the written word and the printed image, still, however, within a broadly topographical framework. Turner was a poet of some sort himself; verses, often extraordinary, from his *Fallacies of Hope*, were frequently added as subtitles and explanations to the entries in Royal Academy and other exhibition catalogues. After the 1820s, Turner increasingly abandoned a topographical approach to landscape in favour of a more abstract one. This can be seen in the work which he produced during the 1830s for illustrated editions of Byron, Scott and Milton as well as the Moxon edition of *Campbell's Poems*, the images being a response to the poetry itself not simply adjuncts to the text.

In fact the *Campbell Illustrations* (see p.53) marked a climax to Turner's work in this field. The illustrations which appeared in 1839 in an edition of *The Epicurean* by his friend Thomas Moore did not meet with success. Thereafter Turner ceased to work as an illustrator.

In 1836 Turner toured France, Switzerland and the Val d'Aosta with his friend, the young Scottish landowner, Hugh Munro of Novar. Munro had known Turner since the mid-1820s and had gathered together a fine collection of the artist's work. A shy and retiring man, he remained, long after the deaths of Walter Fawkes (in 1825) and Lord Egremont (in 1837), one of Turner's few active patrons.

It was also in 1836 that the 17 year-old John Ruskin (1819–1900) first wrote to Turner enclosing a reply to an attack on the artist's work which had appeared in *Blackwood's Magazine*. Ruskin, in championing Turner's work, was to establish himself as one of the finest nineteenth-century writers on art. The two men finally met in 1840. Three years later, and only a year after leaving Oxford, Ruskin published the first volume of his *Modern Painters*. The book appeared, to little public notice, in May 1843. Despite a widespread recognition of his genius, Turner's work had been under increasing criticism during the late 1830s and, apart from his most stalwart patrons, he had had great difficulty selling anything more than the occasional watercolour. Ruskin attempted to show that the manner of painting which was so perplexing Turner's critics was, if anything, as true to nature as any other landscape painting had ever been: his canvases of the late 1830s and early 1840s were powerful expressions of atmosphere and place, not simply expanses of sky and water depicted in yellows and reds. The power and quality of Ruskin's critical account of the artist's work had an almost immediate effect. Already, by the autumn of 1843, Turner's work was in demand once more.

Turner's last finished watercolours were produced during the following years: the great *Heidelberg* from the Vaughan Bequest, of about 1846, dates from this period. In 1845 he had made his last trip abroad, to Dieppe and the coast of Picardy. Turner died on 19 December 1851 at his cottage at 119 Cheyne Walk, Chelsea. He was buried at St Paul's Cathedral on 30 December.

Turner's estate was contested, after his death, by his family and a settlement was not reached for many years. In his will he had left almost £140,000 to establish a charity for 'Decayed Artists'. The contents of his studio at the time of his death, known as the Turner Bequest, was left to the Nation, to be housed together in a single gallery. Turner's wishes were only fulfilled with the opening of the Clore Gallery extension to the Tate Gallery in London in 1987.

THE VAUGHAN BEQUEST
OF TURNER WATERCOLOURS

ALTHOUGH HENRY VAUGHAN (1809–1899) had a remarkable and diverse collection of pictures, he is chiefly remembered now for the outstanding group of Turner watercolours which he assembled. His father was a Southwark hat-manufacturer and when he came of age Vaughan succeeded to a large fortune, allowing him to spend much of his time both travelling and collecting. Little is known of the details of his collecting activities and few of his collections (including the Turners) now have a firm provenance. A group of seven drawings attributed to Michelangelo which he purchased at the Woodburn Sale at Christie's in 1860 was given to the British Museum in 1887 (five are still accepted as autograph). He also bequeathed three Raphael drawings to the Museum (together with one now accepted as by Penni and another by Polidoro).

Vaughan purchased John Constable's *Haywain* from Christie's in 1866, presenting it, that same year, to the National Gallery in London. He also bequeathed a Constable oil sketch related to the National Gallery of Scotland's *Dedham Vale*, to the National Gallery (now transfered to the Tate Gallery), together with a number of paintings by contemporary Victorian artists and an important portrait by Gainsborough of his daughters. Two full-scale oil studies by Constable, for the *Haywain* and *The Leaping Horse*, a marble *bas-relief*, then attributed to Donatello, and five watercolours by Turner went to the Victoria and Albert Museum.

Vaughan's collection of Turner watercolours, described in his obituary in the *Athenaeum Magazine* (December 2, 1899) as being 'singularly choice and indeed hardly paralleled in this country', was clearly brought together in an attempt to be as comprehensive as possible, with examples from every period of the artist's career, chosen with as discerning an eye for quality as for condition. Such preoccupations were remarkably similar to those which concerned John Ruskin, another great collector of Turner's work. Ruskin, the champion of Turner in his *Modern Painters*, the first part of which was published in 1843, had already given part of his fully representative collection of Turner watercolours to the University of Oxford and a

similar group to the University of Cambridge in 1861. The conditions applying to his gifts stipulated that the watercolours be kept together in a cabinet and not kept on permanent display, because of the danger of fading if continually exposed to light. They were to be shown 'only to persons really interested in art'. Otherwise they were to be kept solely for the use of students of the university 'who may wish to copy them'.

Ruskin had certainly formulated these conditions by the time that he came to arrange the Turner Bequest in the National Gallery (since 1987 in the Tate Gallery). Groups were chosen for study and for circulating exhibitions in the provinces (including Dublin and Edinburgh). Finberg, in his introduction to the *Inventory of the Turner Bequest*, published in 1909, quotes Ruskin's report on the collection written in 1858: 'Five or six collections each illustrative of Turner's modes of practice, might easily be prepared for the Academies of Edinburgh, Dublin and the principal English manufacturing towns'. This is conceivably the germ of the idea embodied in Vaughan's will. There is no tangible evidence of contact between Vaughan and Ruskin but both were members of the Burlington Fine Arts Club founded in the 1850s. (Another notable member was H. A. J. Munro of Novar, one of Turner's greatest patrons). In any event it was the conditions established by Ruskin for his Turner gifts to Oxford and Cambridge which Vaughan followed when his own collection of watercolours was divided amongst the National Galleries of Ireland and Scotland, the Victoria and Albert Museum and the British Museum (which received the group of preliminary drawings for the *Liber Studiorum*. These have now been transfered to the Tate Gallery). Although, the division is slightly imbalanced (the three early topographical watercolours went to Dublin, including a marvellous view of Edinburgh from Salisbury Crags), most of the cohesive groups were preserved: the drawings for the *Picturesque Views of the Southern Coast* are in Dublin, while those connected with the series *Picturesque Views in England and Wales* and the illustrations to *The Collected Works of Sir Walter Scott* are now in Edinburgh.

2 Rye, Sussex

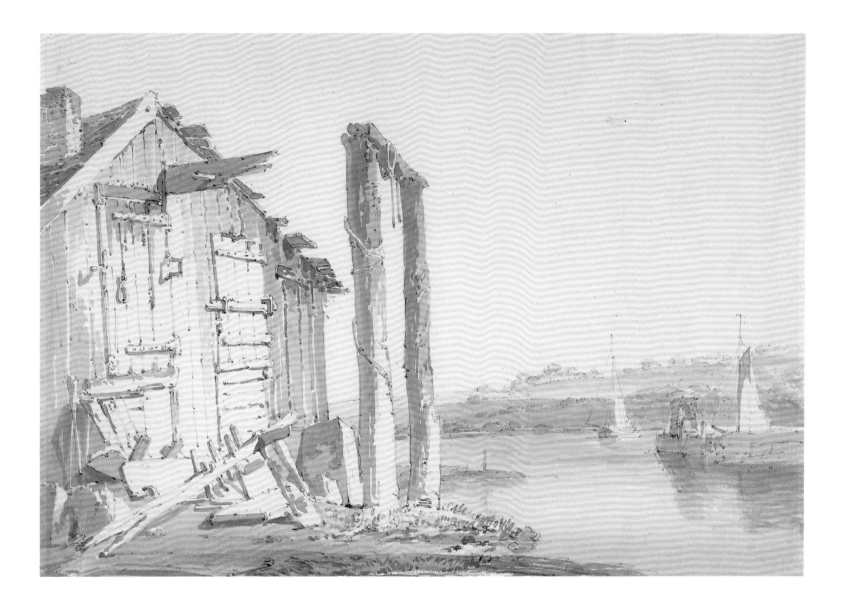

3 The Medway

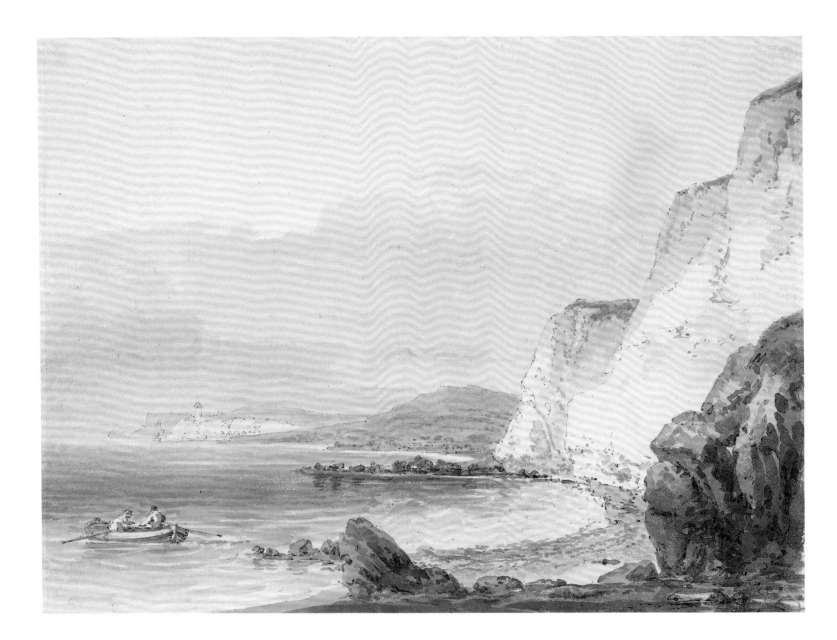

4 Beachy Head looking towards Newhaven

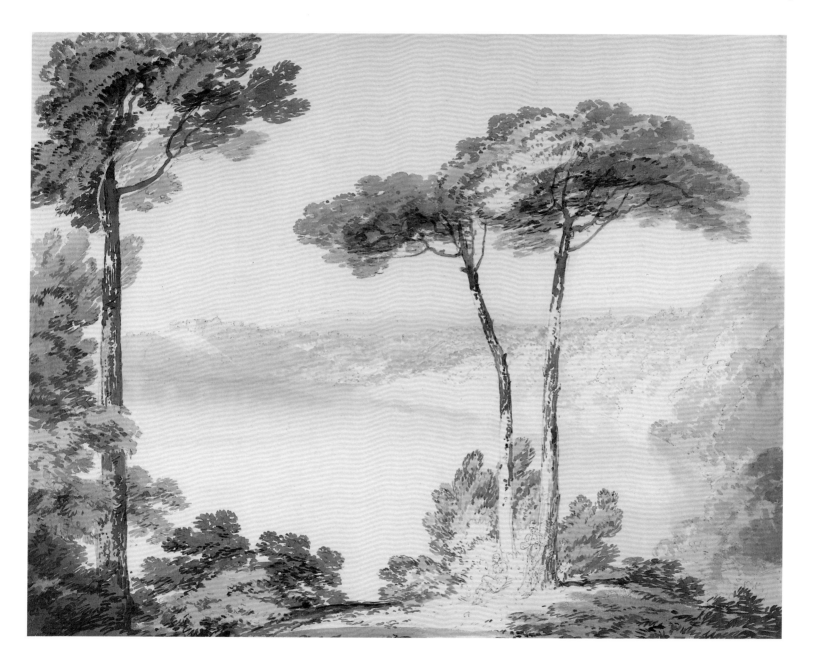

5 Lake Albano

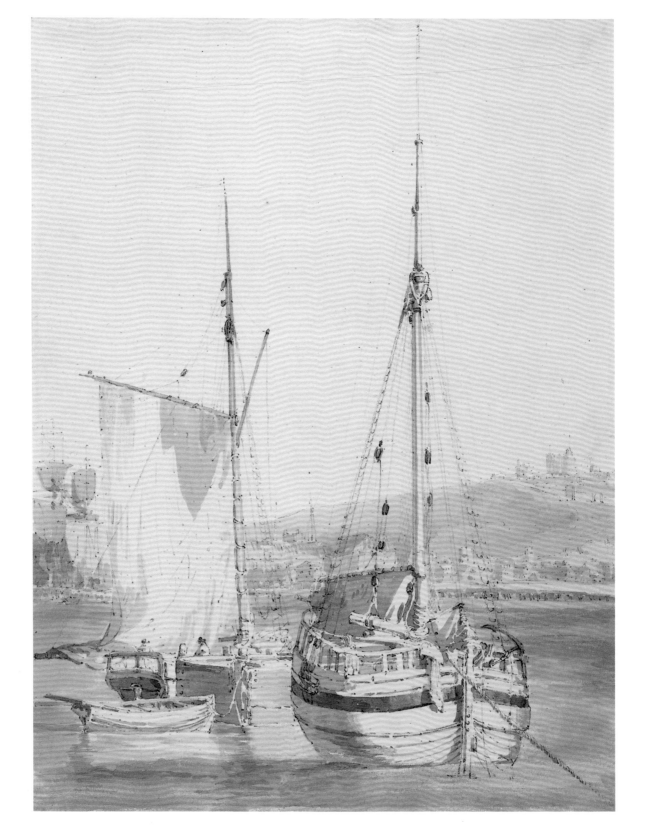

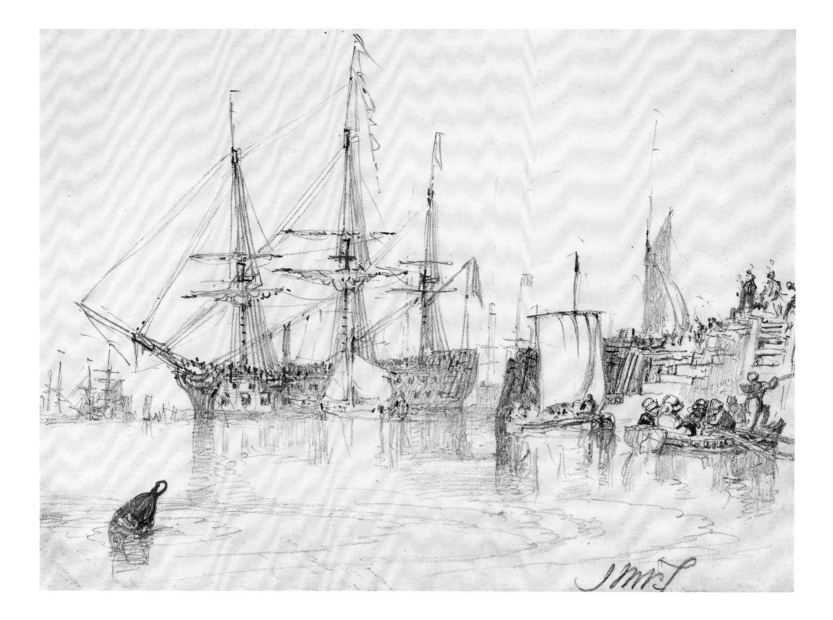

facing page

6 Old Dover Harbour

above

7 Man of War

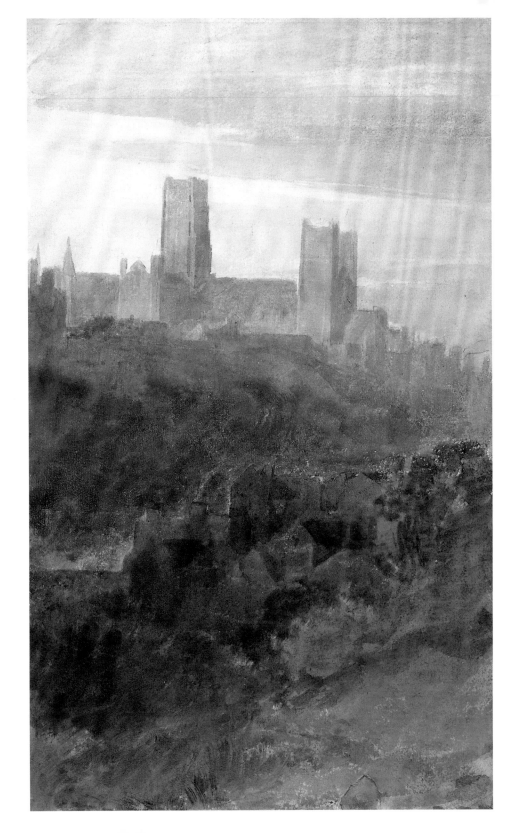

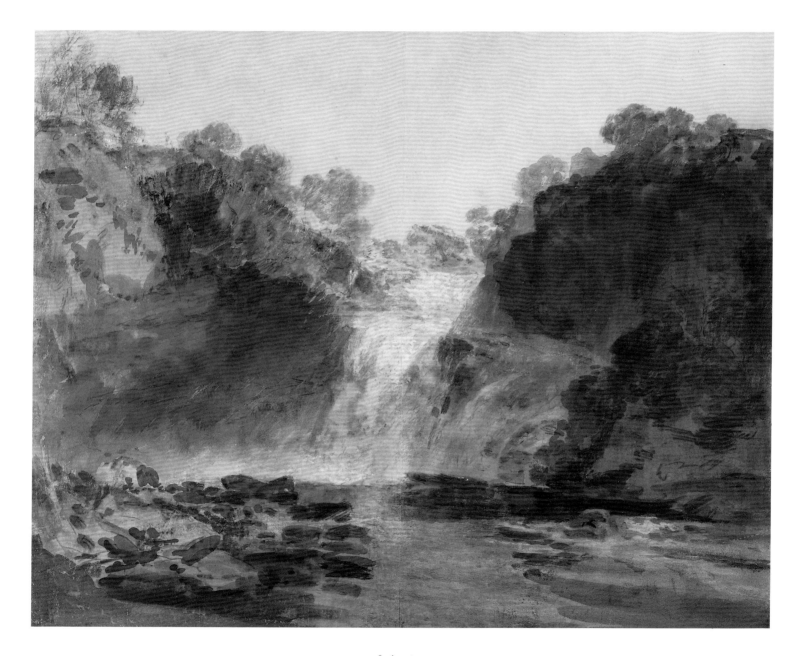

facing page
8 Durham
above
9 The Falls of Clyde

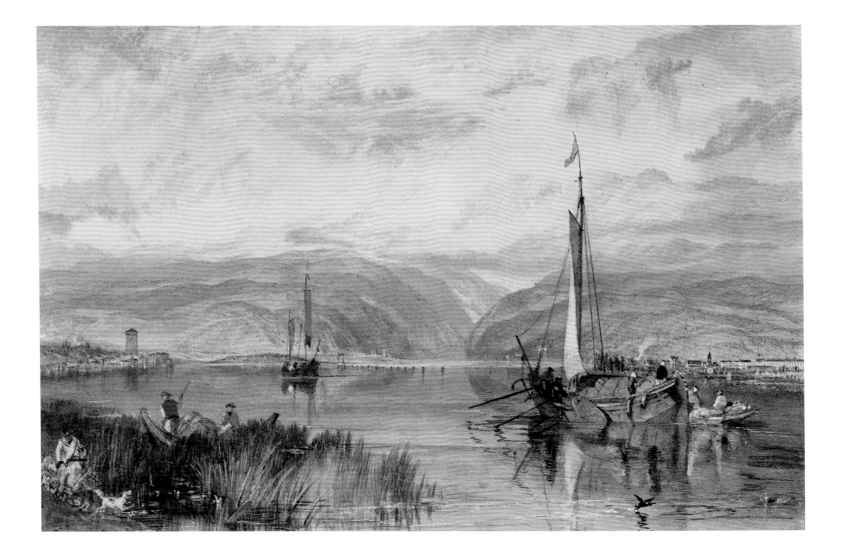

10 Neuwied and Weise Thurn, with Hoch's Monument on the Rhine, looking towards Andernach

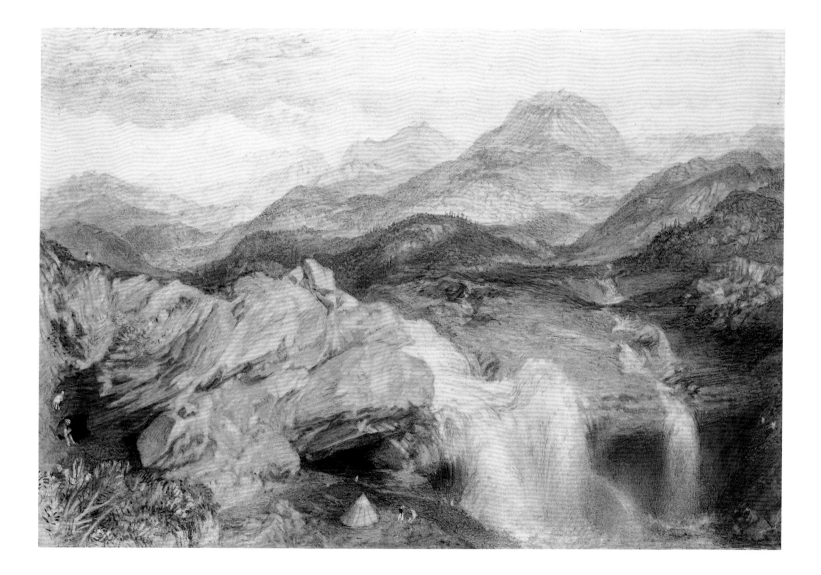

11 Falls near the Source of the Jumna in the Himalayas

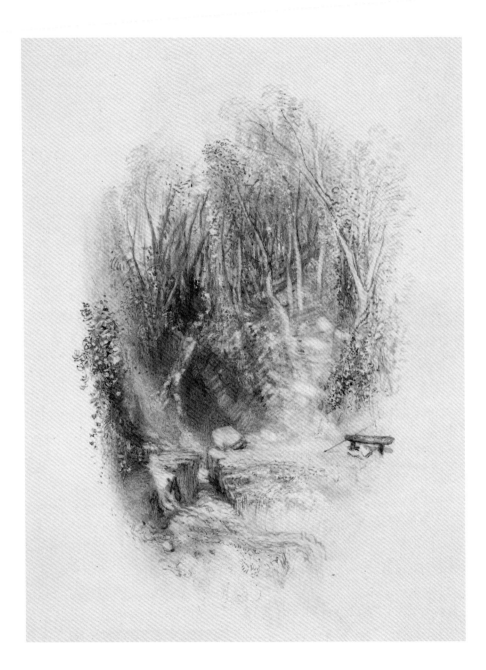

12 Rhymer's Glen, Abbotsford

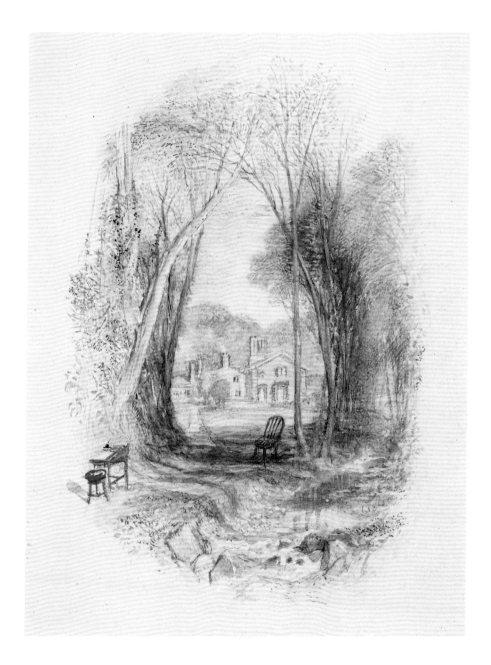

13 Chiefswood Cottage at Abbotsford

14 Melrose

15 Loch Coruisk, Skye

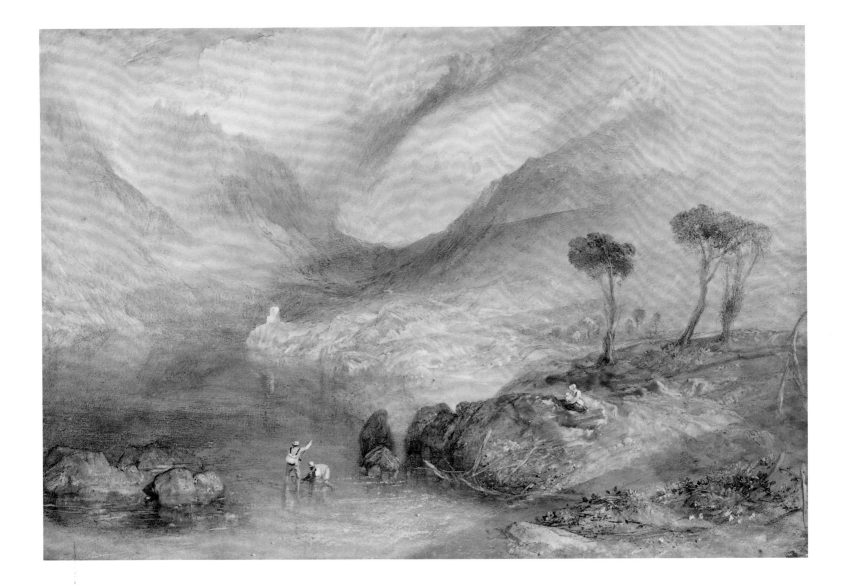

16 Llanberis Lake and Snowdon – Caernarvon, Wales

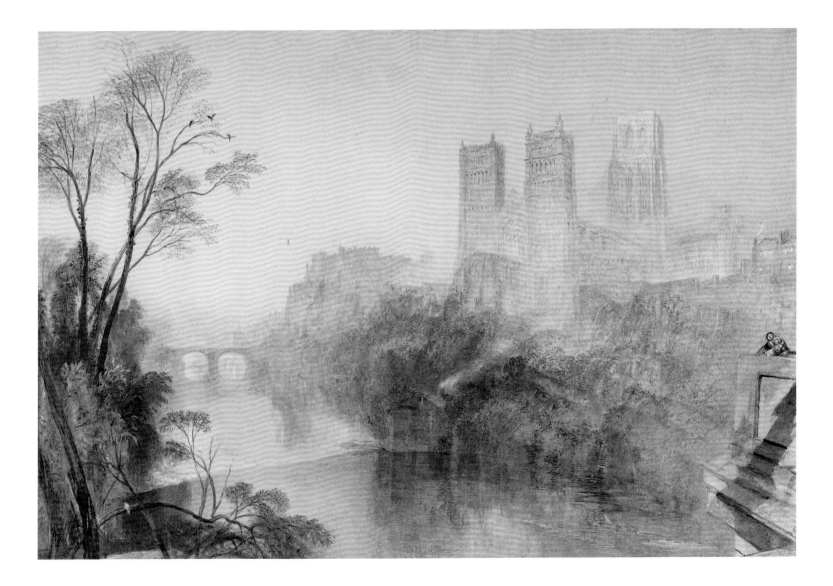

17 Durham

18 Sion, Capital of the Canton Valais

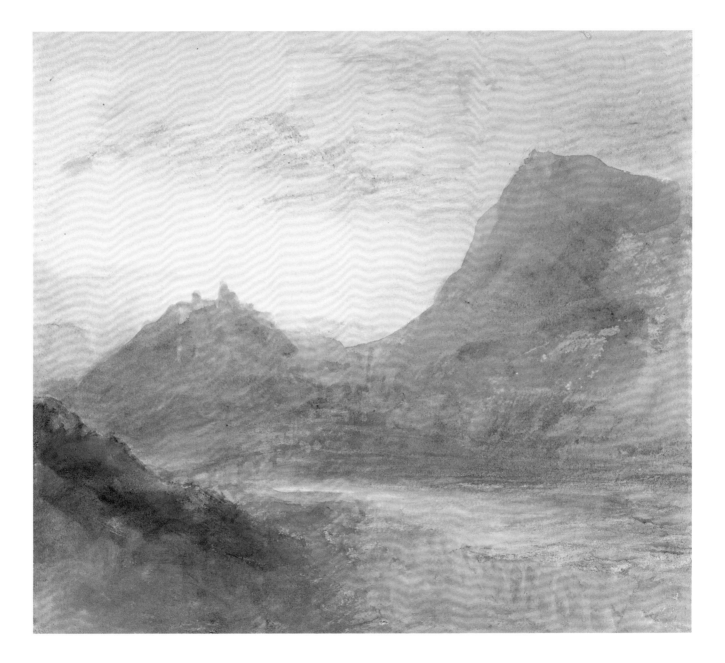

19 Sion, Rhône (or Splügen)

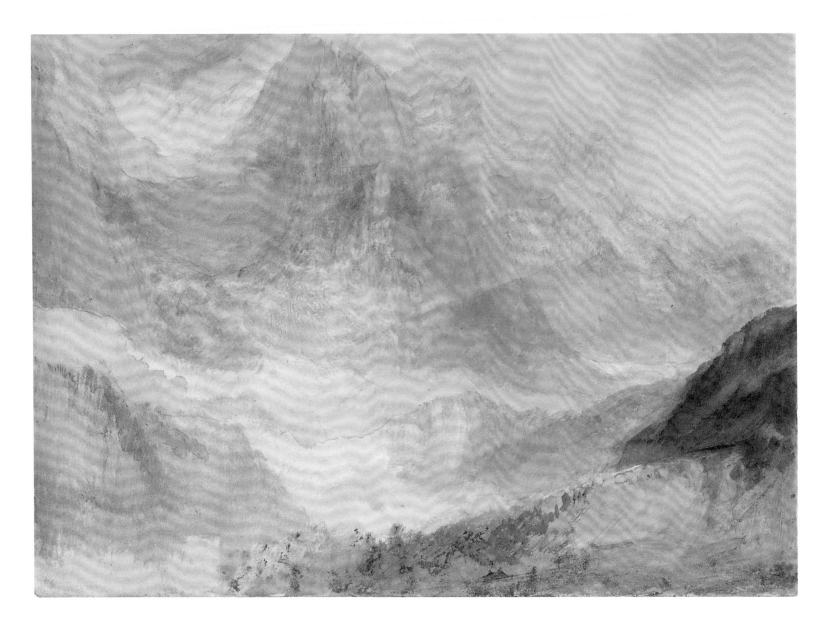

20 Monte Rosa (or the Mythen, near Schwytz)

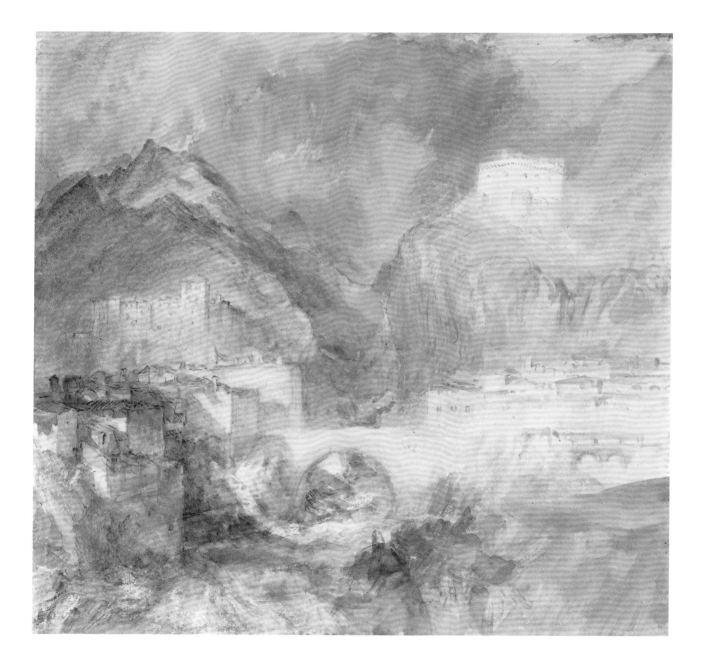

21 Verrès in the Val d'Aosta

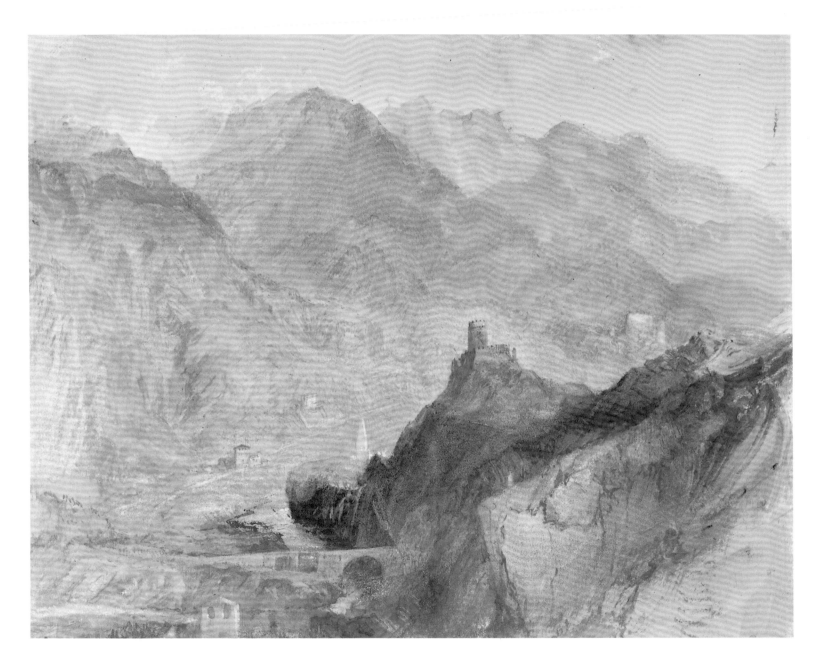

22 Chatel Argent, in the Val d'Aosta, near Villeneuve

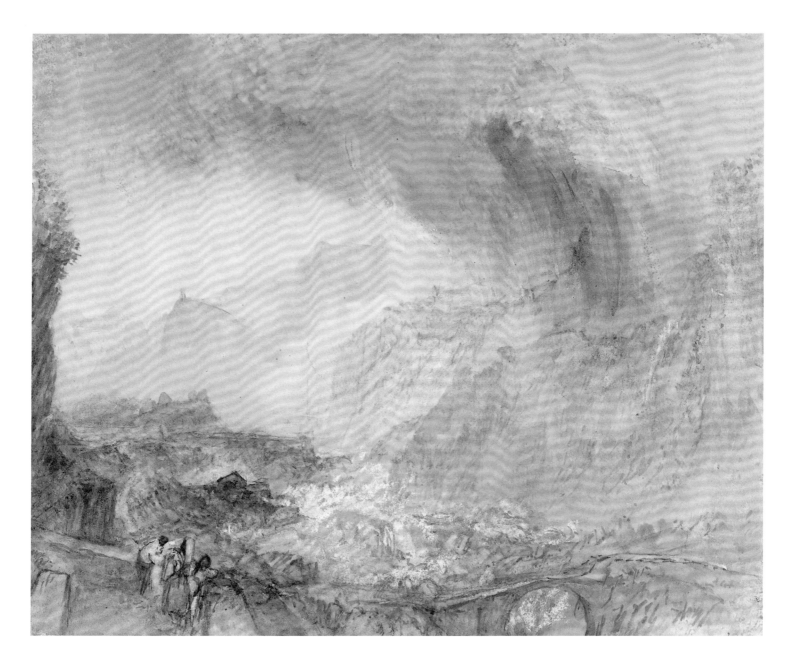

23 The St Gothard Pass at the Devil's Bridge

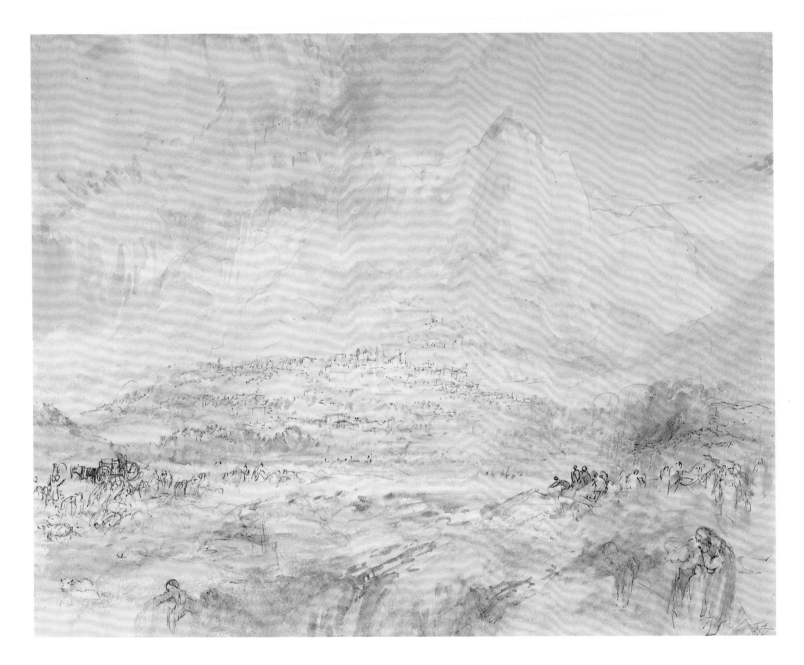

24 Schwyz

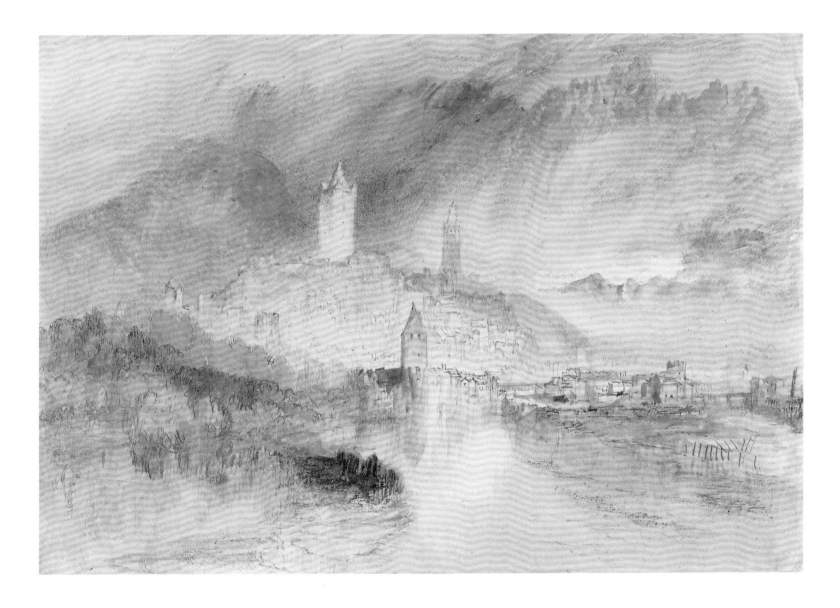

25 Thun

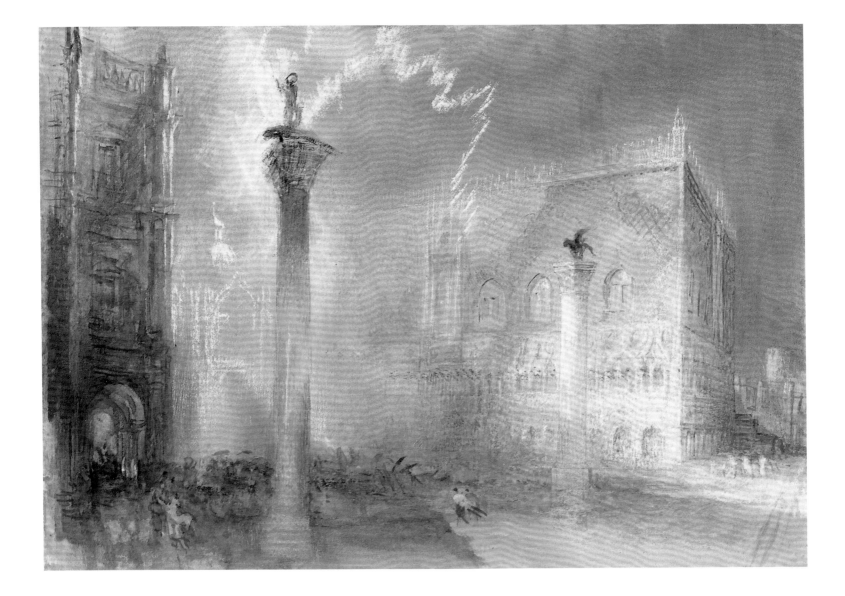

26 The Piazzetta, Venice

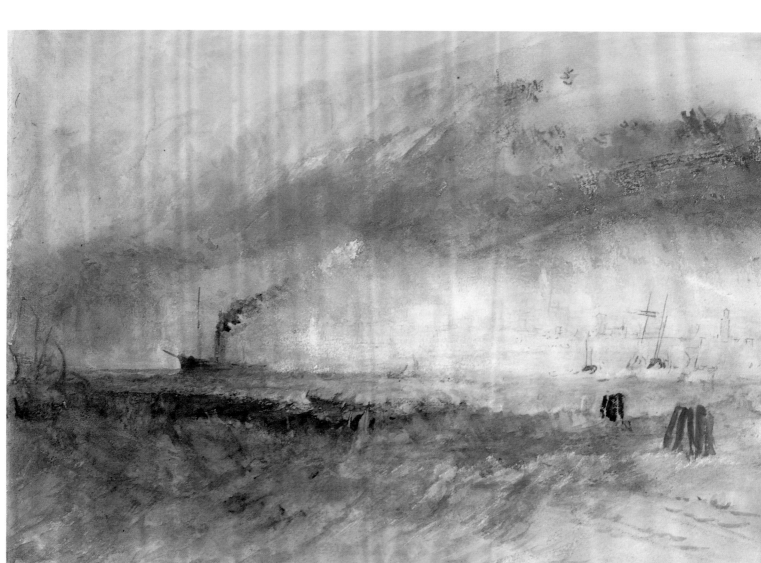

27 Venice from the Laguna

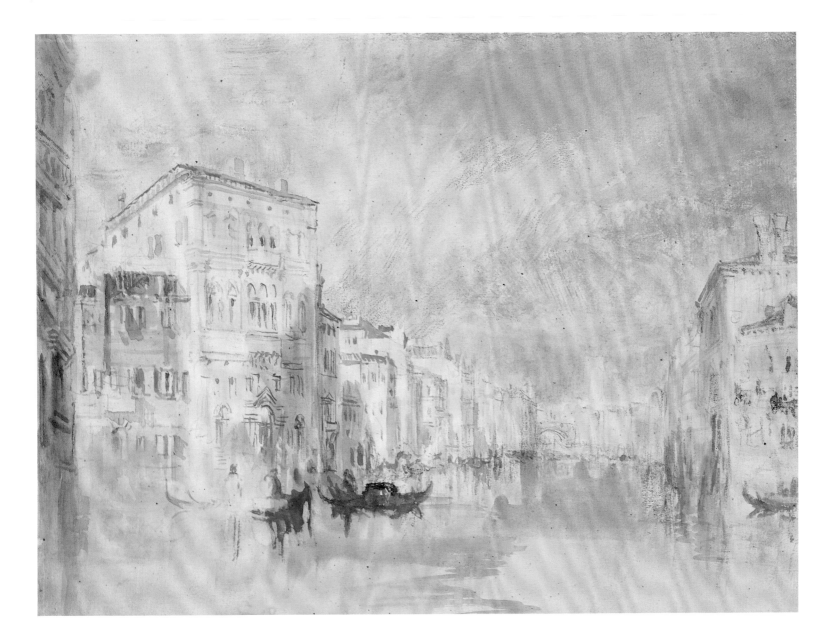

28 The Palazzo Balbi on the Grand Canal, Venice

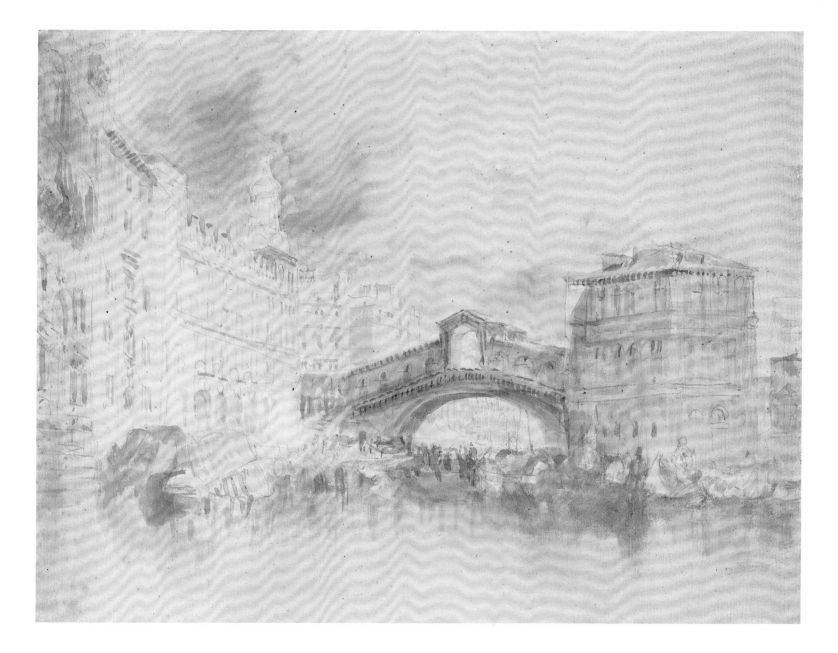

29 The Rialto, Venice

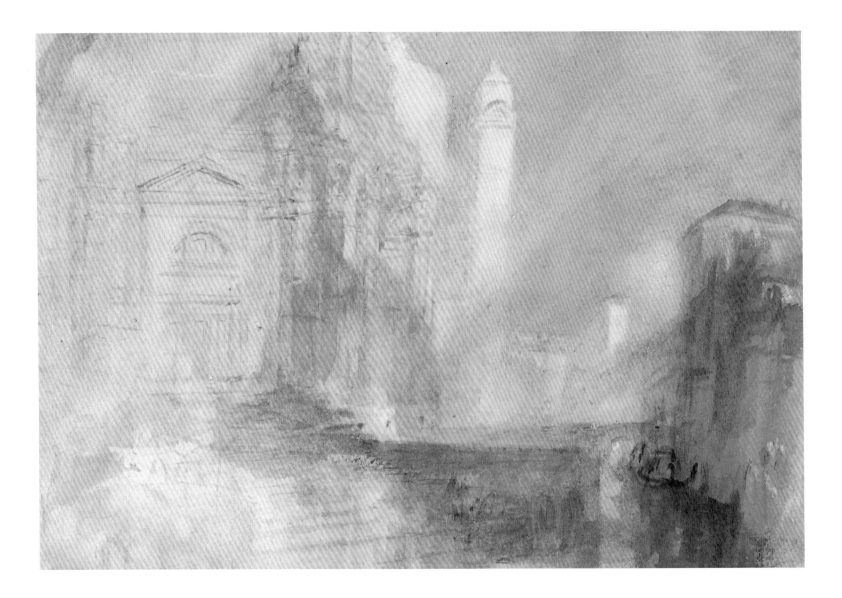

30 The Grand Canal by the Salute, Venice

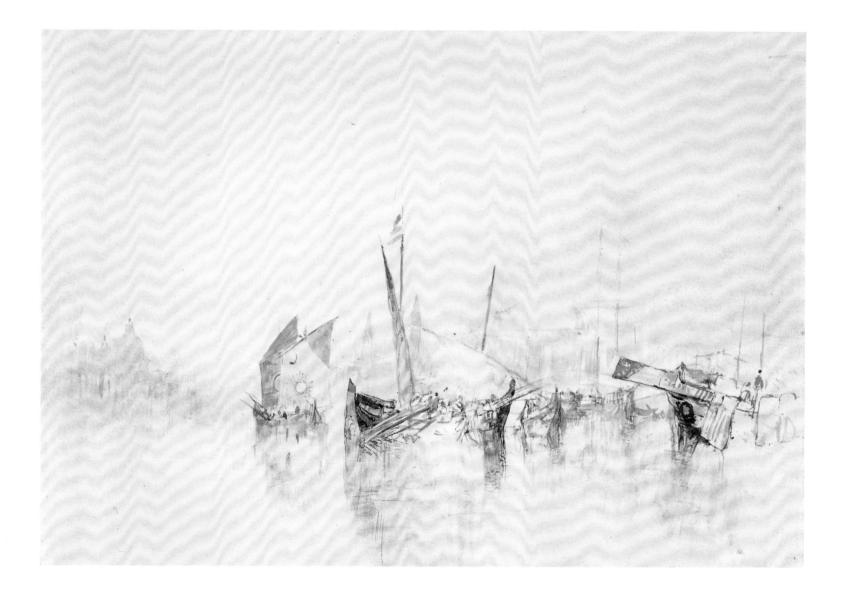

31 The Sun of Venice

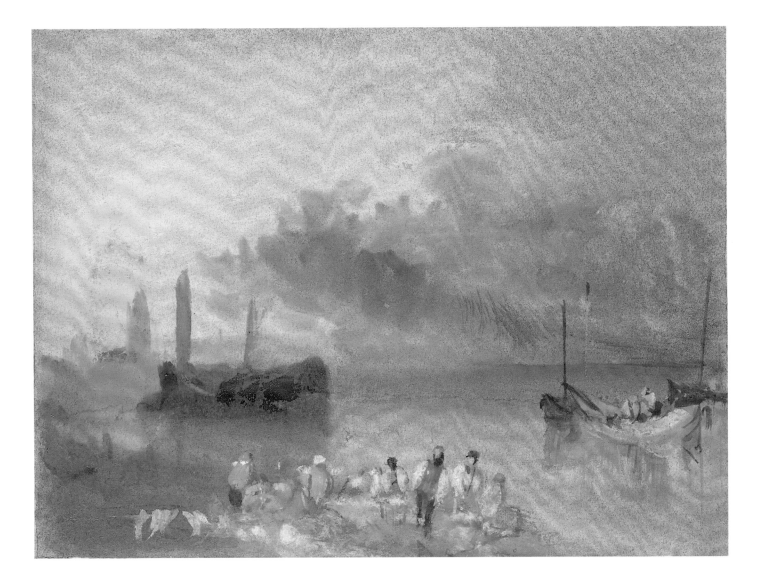

32 Harbour View

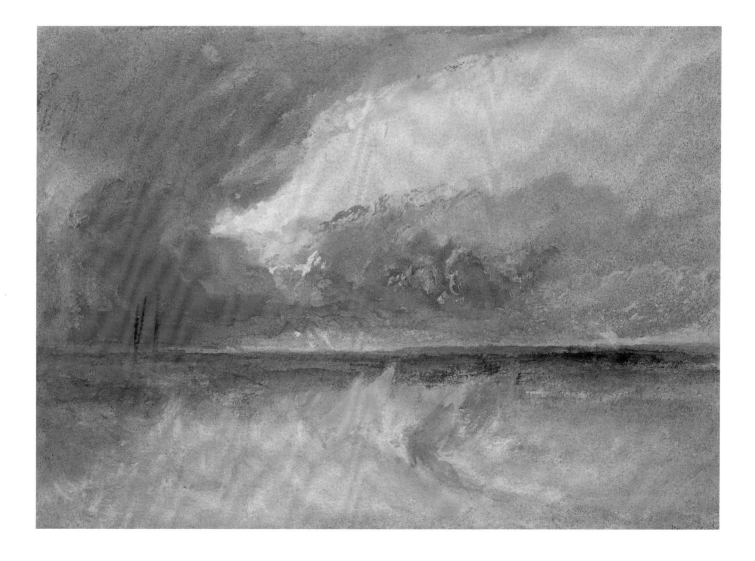

33 Sea View

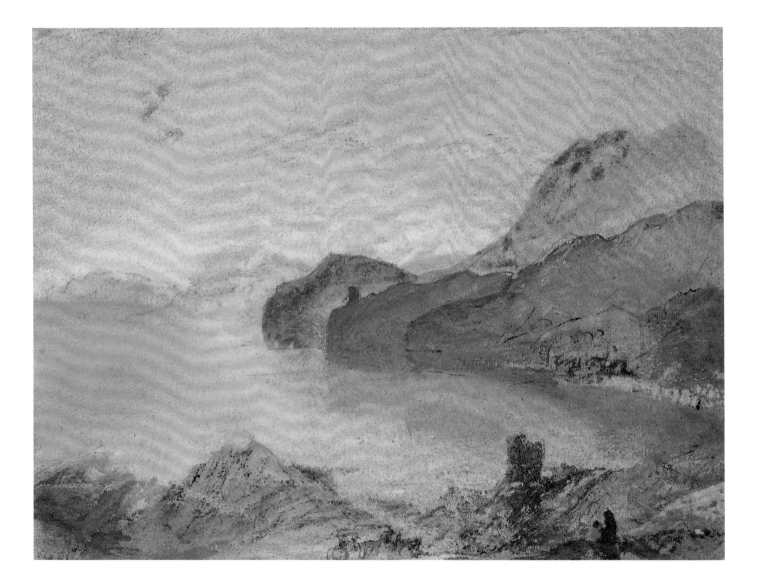

34 Lake Como looking towards Lecco

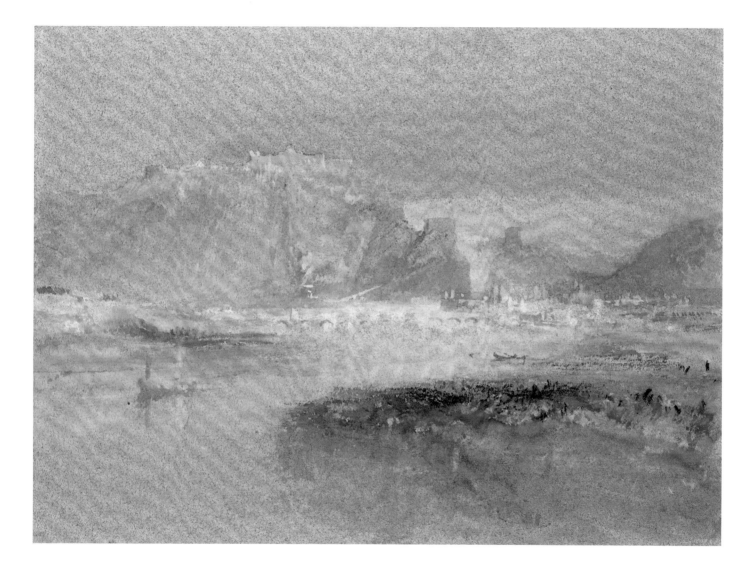

35 Ehrenbreitstein from the Mosel

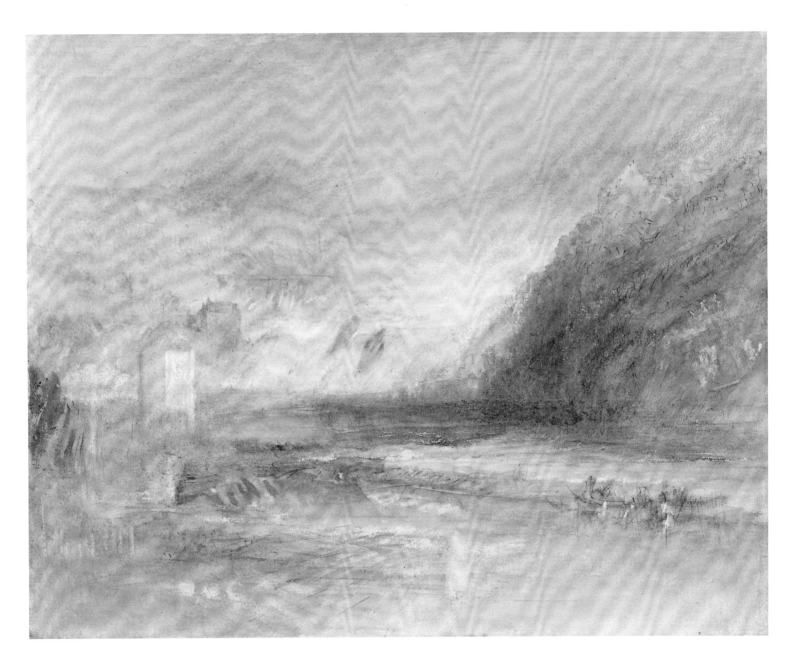

36 Falls of the Rhine at Schaffhausen, Front View

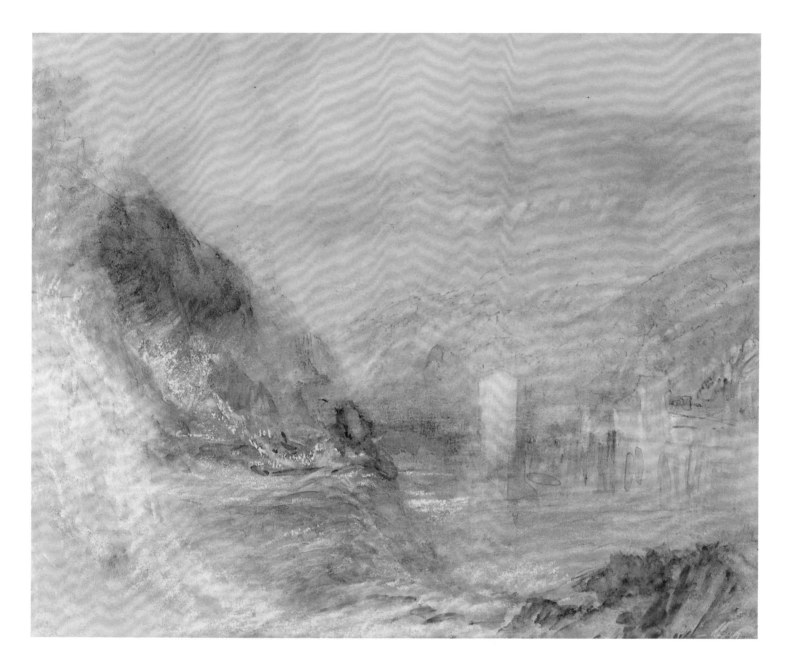

37 Falls of the Rhine at Schaffhausen, Side View

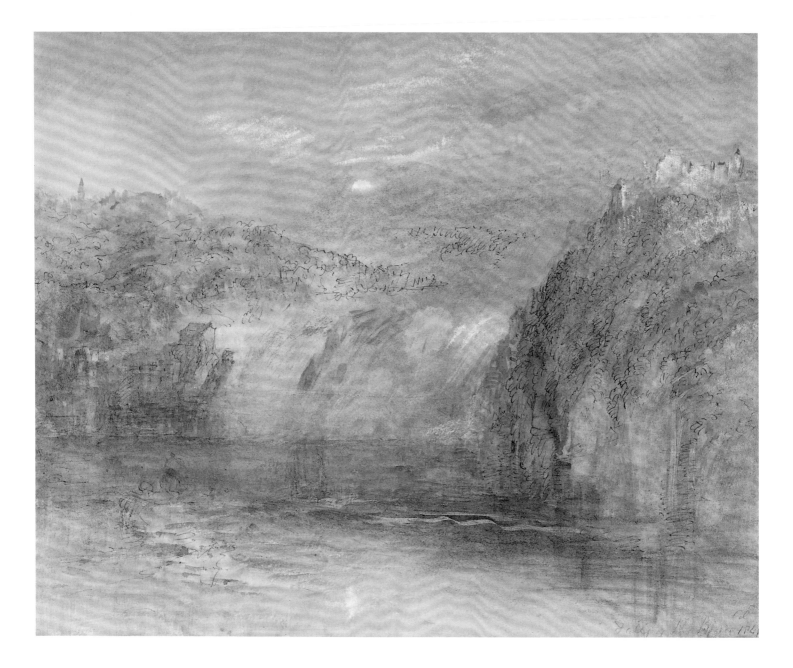

38 Falls of the Rhine at Schaffhausen, Moonlight

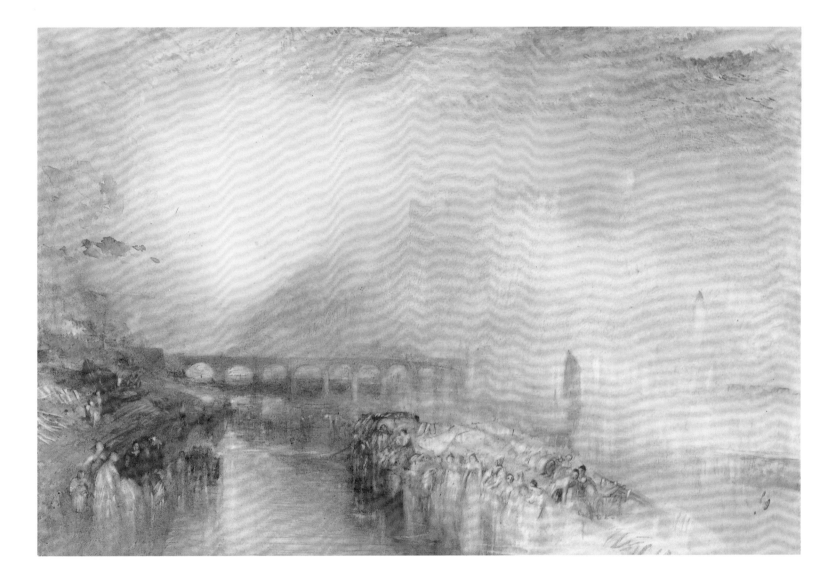

39 Heidelberg

THE TWENTY WATERCOLOURS which Turner produced for Edward Moxon's edition of *The Poetical Works of Thomas Campbell* published in 1837 are today unique among his illustrations in remaining together as a set. On loan from 1970 to the National Gallery of Scotland through the generosity of Mrs M. D. Fergusson, the drawings were accepted by H. M. Treasury in lieu of inheritance tax from her estate and allocated to the Gallery in January 1988.

The circumstances surrounding the commission for the Campbell illustrations and their early provenance are confused. Contemporary sources give us several contradictory accounts of both the commission itself and of subsequent events. William Beattie (Beattie, 1849), Campbell's biographer, quotes a letter from the poet to a Mr W. Gray in November 1837. Campbell says that he paid Turner twenty-five guineas for each of the twenty drawings, having been told that they were like 'bank notes' which would always fetch the price paid for them. On this assumption Campbell tried to sell the drawings in order to recoup his initial outlay. He could find no purchaser. Hearing that Campbell intended to dispose of the illustrations by lottery, Turner, says Beattie, bought back the drawings for 200 guineas.

Walter Thornbury, Turner's first biographer, provided two further accounts of the story, the first being that Campbell could not afford to pay for the drawings and that Turner asked for them back and later gave them to a friend. Thornbury's second story is related to the account given by Beattie: that Campbell, being unable to find a market for the drawings, sold them back to the artist. Edward Goodall's son provided a final version. Goodall, the engraver of most of the set of illustrations, had agreed with Moxon, the publisher, that Turner be given the commission and that publisher and engraver should share the costs and the profits. When the arrangement fell through Turner agreed to lease his illustrations to Goodall for £5 each, reclaiming them after the engravings had been made.

If no satisfactory conclusion can be drawn from these stories, Campbell's letter quoted by Beattie and Thornbury's second story may give us the best clue to what happened. The drawings were obviously not marketable: they had never been intended primarily for display and Campbell describes them as being merely 'bits of painted pasteboard'. Although Turner had leased his drawings for Rogers' *Italy* to the engraver it would not seem likely, as Goodall's son suggests, that this was the case with the *Campbell*. Turner may well have seen fit to keep the drawings from the market. They were not at all in the same vein as his contemporary exhibition pieces in watercolour. Although we may assume that he regained possession of the vignettes, it cannot be the case that they remained in Turner's possession at the time of his death. They would otherwise surely have remained with the Turner Bequest. All that we can know for certain is that by 1896 they had come into the possession of Sir Donald Currie, who in that year lent them to an exhibition at the Guildhall in London. Sir Donald, founder of the Castle, later the Union Castle Steamship Company, amassed an outstanding Turner collection before his death in 1909. The vignettes passed, by descent, to Mrs Fergusson who died in November 1986.

It is not known how the sixteen poems which Turner's twenty vignettes illustrate were chosen. Other shipwreck subjects, battle scenes, tales of chivalric romance and invocations to national pride in many of the sixty-seven other poems in the edition, might have served his purpose equally well. Within a particular poem, indeed, Turner may take as his starting-point a single topographical reference, for example, Ehrenbreitstein in *Ode to the Germans* (D 5171); or he may try to evoke the whole piece as in *The Soldier's Dream* (D 5163).

Ruskin had come to know Turner through engravings, and later admired that from *The Andes* (D 5154) as 'one of the very noblest, most faithful, most scientific statements of mountain form which even Turner has ever made …'. This might seem to be a remarkable statement when looking at the watercolour itself; the effect is noble, certainly, but scarcely a 'faithful' or 'scientific' image of a mountain range which the artist had never seen. In fact Turner has provided the engraver with topographical information in a decidedly abstract way. Forms are built up not as the engraver would, in linear terms, but with strokes of pure colour, sometimes as in the vignette to *Lines on*

the Camp Hill, Near Hastings (D 5169); or in the depiction of Mount Sinai from *The Pleasures of Hope* (D 5156), creating quite startling effects. Figures set into these poetic landscapes are similarly modelled with pure colour; Lochiel's plaid and targe, green, red and yellow; the pink and yellow shawl lying on the bench in *The Beech Tree's Petition* (D 5168) or the red and green uniforms of the soldiers in *Hohenlinden* (D 5161). To paraphrase Campbell, distance lent enchantment to the reds and blues of the mountain ranges; the same colours bring the figures into the foreground plain of the vignettes, creating the powerful effects of tremendous ranges of scale so beloved by Turner.

40 At Summer Eve (Illustration to *The Pleasures of Hope*)

41 The Andes (Illustration to *The Pleasures of Hope*)

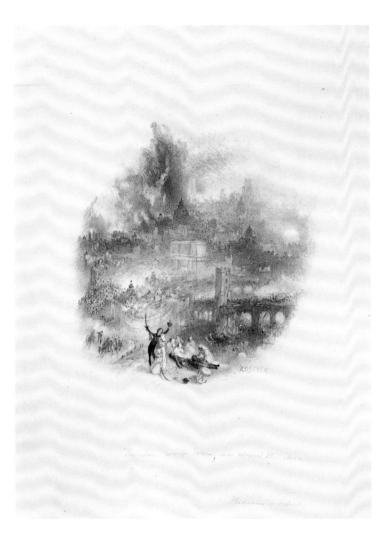

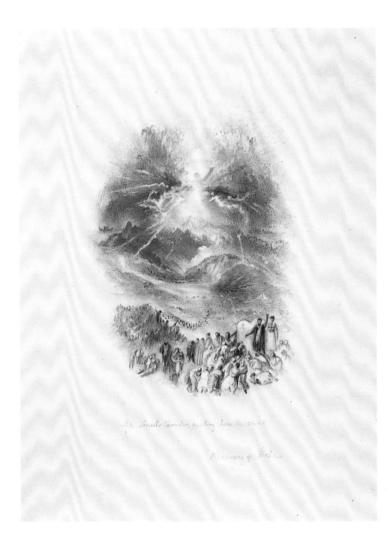

42 Kosciusko (Illustration to *The Pleasures of Hope*)

43 Sinai's Thunder (Illustration to *The Pleasures of Hope*)

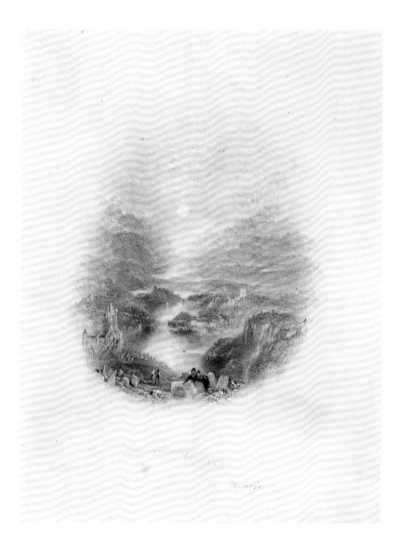

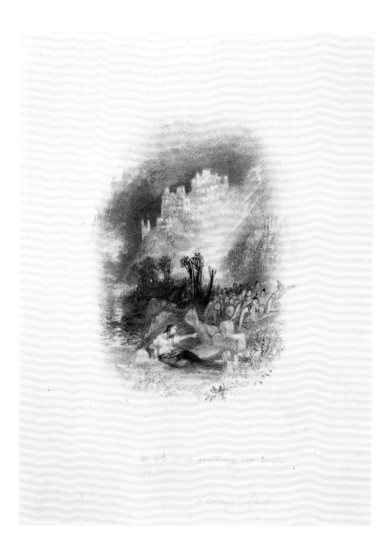

44 A Swiss Valley: Theodric

45 O'Connor's Child

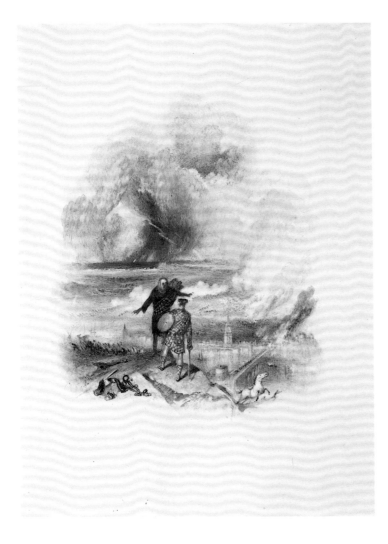

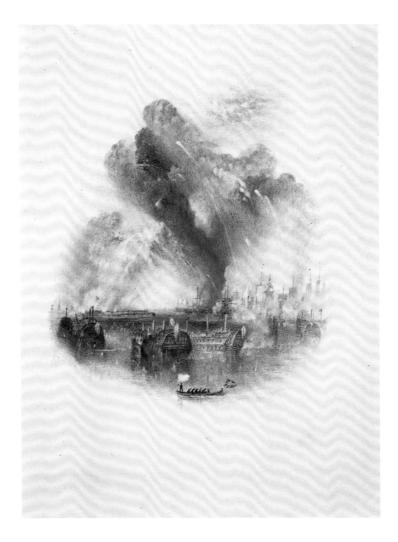

46 Lochiel's Warning 47 Battle of the Baltic

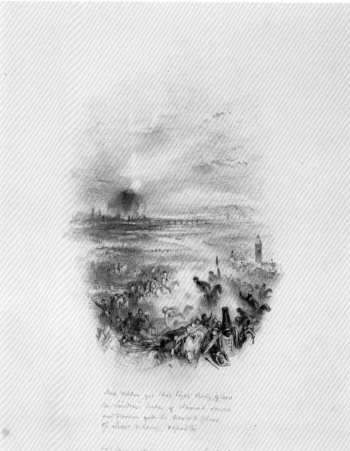

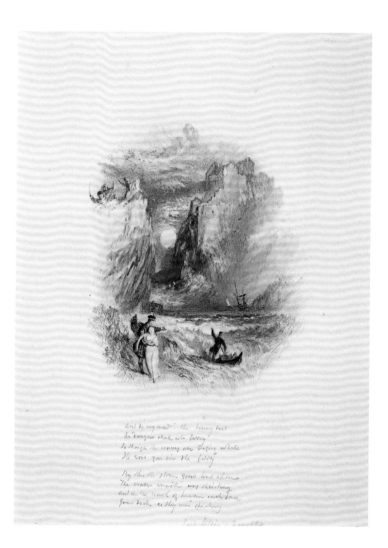

48 Hohenlinden

49 Lord Ullin's Daughter

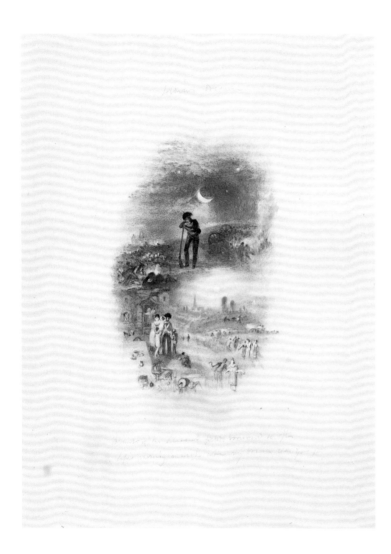

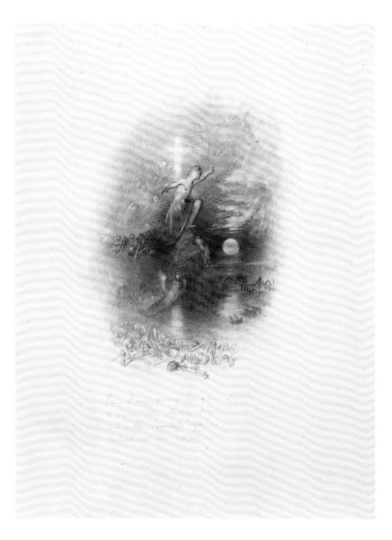

50 The Soldier's Dream 51 The Last Man

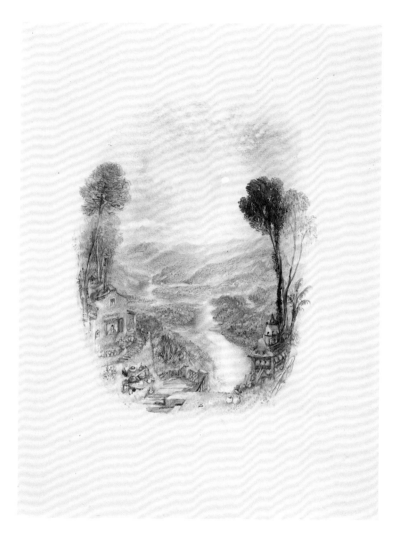

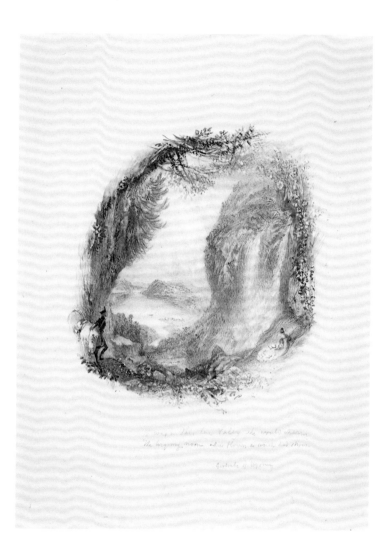

52 The Valley (Illustration to *Gertrude of Wyoming*)

53 The Waterfall (Illustration to *Gertrude of Wyoming*)

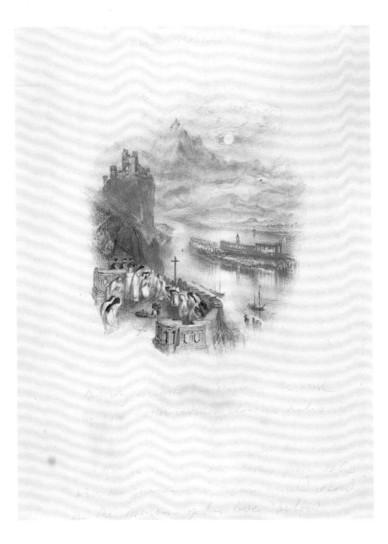

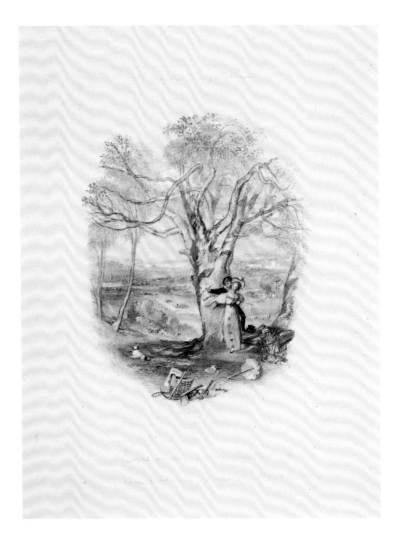

54 The Brave Roland 55 The Beech Tree's Petition

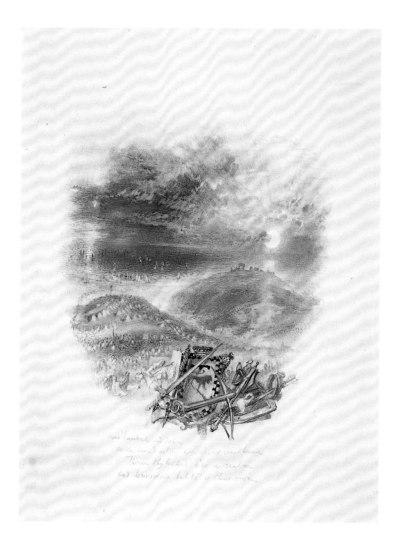

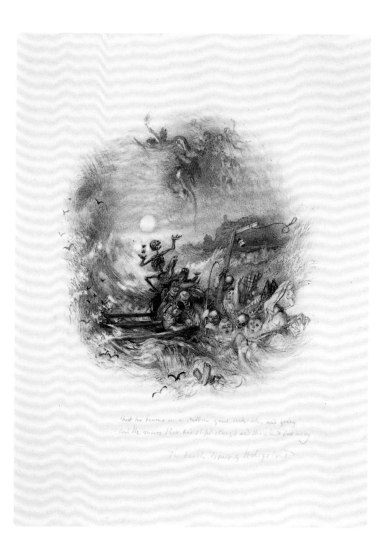

56 On Camp Hill, near Hastings

57 The Death Boat of Heligoland

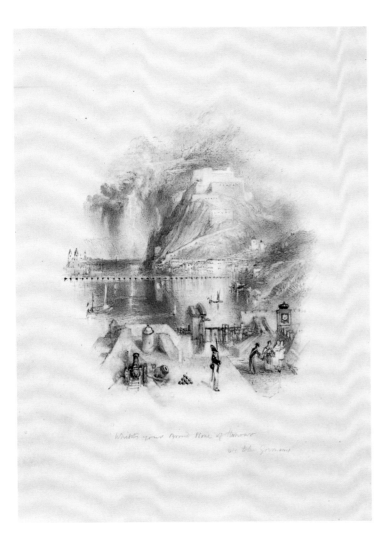

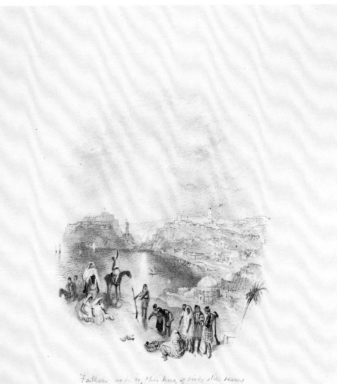

58 Ode to the Germans: Ehrenbreitstein

59 The Dead Eagle

OTHER WORKS BY
TURNER IN THE COLLECTION

SINCE 1900, when Henry Vaughan bequeathed thirty-eight of his Turner watercolours to the National Gallery of Scotland, the collection has continued to grow, by gift, by bequest and by purchase. Two large gifts in particular should be mentioned.

In 1976 the Gallery received a bequest of fifty-six English watercolours from the estate of Miss Helen Barlow, of which three were by Turner. Two of the drawings are particularly fine examples of early, 'Monro School', works, the third, the unusual gouache of *Caley Hall*, once in the possession of Turner's great patron, Walter Fawkes. *Caley Hall*, like many of her drawings, had belonged to Miss Barlow's father, Sir Thomas Barlow, Bart., physician to Queen Victoria, King Edward VII and King George V and a notable collector of English watercolours.

Most of the Gallery's collection of prints after Turner come from one gift, made in 1952 by the distinguished archaeologist, Sir Leonard Woolley (1880–1960). This large collection includes many early states and fine impressions of the plates for which some of the artist's finest drawings were made. Turner's vital role in the early ninetenth century development of high quality, mass-produced prints and illustrated books is discussed above, for example in relation to the Gallery's watercolour *Illustrations to the Poetical Works of Thomas Campbell* (for which, sadly, we do not have a set of the engraver's proofs).

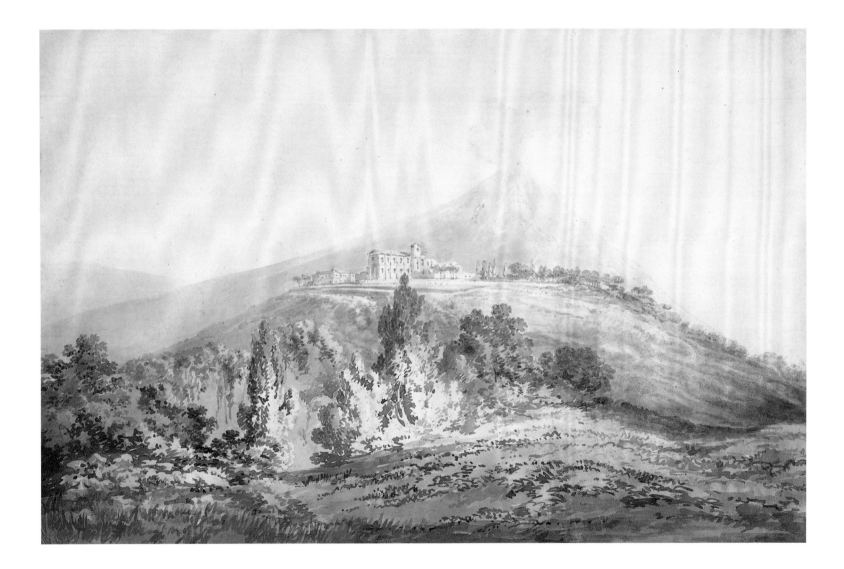

60 Vesuvius and the Convent of San Salvatore

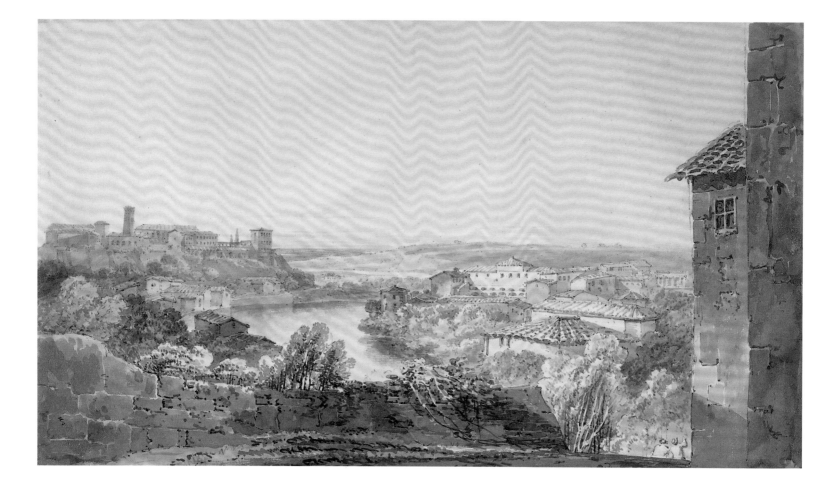

61 Rome: The Tiber with the Aventine on the Left

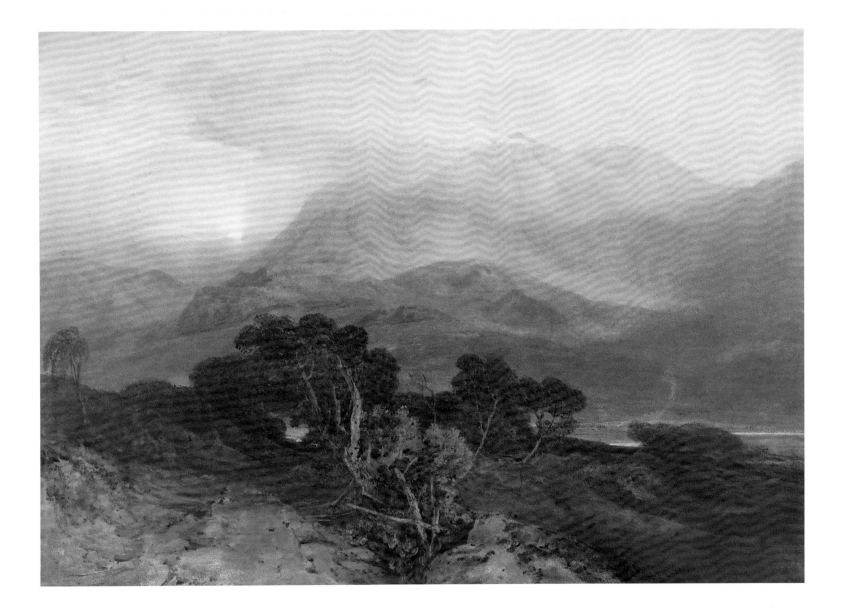

62 Mount Snowdon, Afterglow

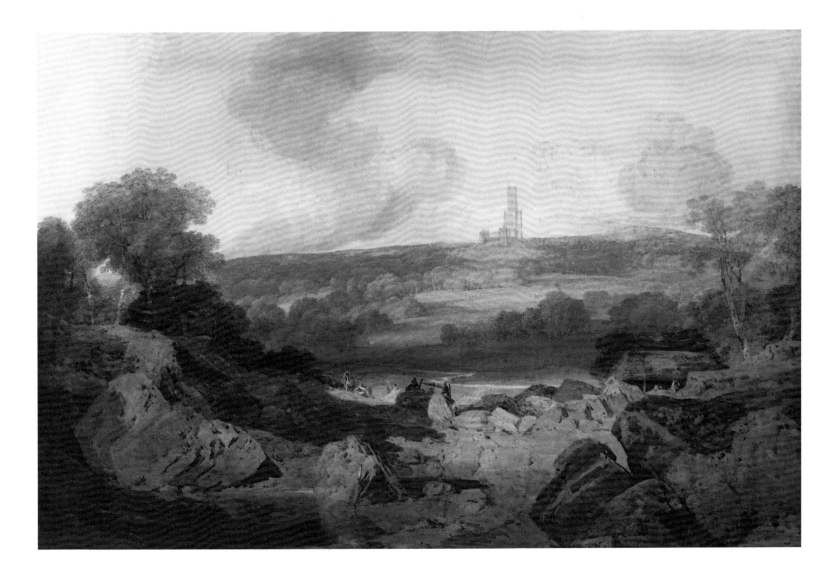

63 East View of Fonthill Abbey, Noon

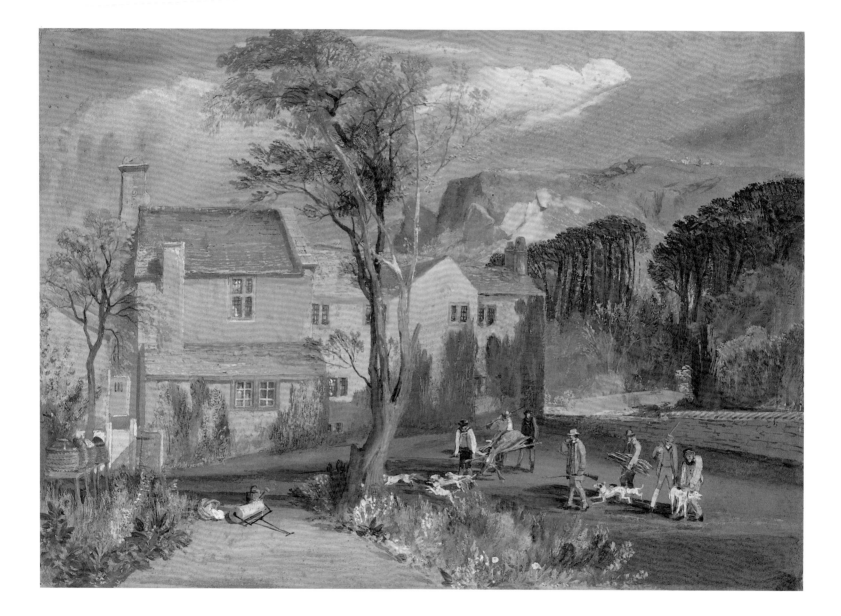

64 Caley Hall, Yorkshire with Stag Hunters Returning Home

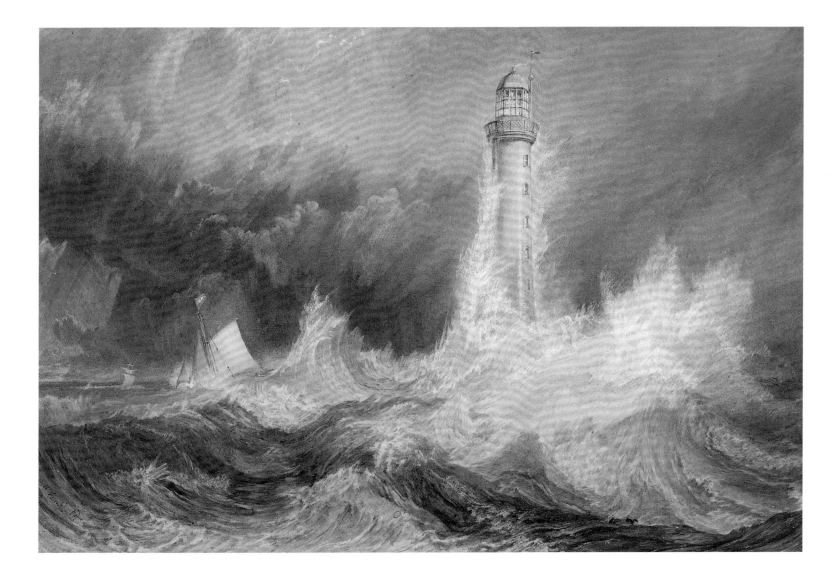

65a The Bell Rock Lighthouse

CATALOGUE NOTE

The catalogue is arranged in seven sections:

§ 1

Oil Painting

§ 2

The Vaughan Bequest

§ 3

Illustrations to *The Poetical Works of Thomas Campbell*

§ 4

Other Drawings by Turner in the Collection

§ 5

Drawings attributed to Turner

§ 6

Drawings formerly attributed to Turner

§ 7

Prints after Turner

Dimensions are given in centimetres,
height precedes width.

For abbreviations refer to *Bibliography & Exhibitions*
at the end of the book.

Where relevant, the first reference to literature
on a work is to A. Wilton, *J. M. W. Turner
His Life and Art*, New York,

1979

A COMPLETE CATALOGUE OF WORKS BY TURNER IN THE NATIONAL GALLERY OF SCOTLAND

§1 Oil Painting

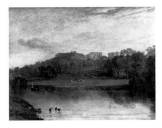

1

Somer-Hill, near Tunbridge, the Seat of W. F. Woodgate, Esq.

NG 1614

Oil on canvas 91.5 × 122.3 cm

Provenance: Bought in at James Alexander's sale, Christie's 24 May 1851 (38). (The painting is there described as 'painted for Mr Alexander'. He only purchased the house from Woodgate in 1816 however.); Wynn Ellis sale Christie's 6 May 1876 (120), bought Agnew; Ralph Brocklebank 1878; His sale, Christie's 7 July 1922 (71).

Exhibited: R.A.1811 (177); Guildhall 1899 (17); Tate Gallery 1931 (53); R.A.1934 (451); R.A.1974–75 (158)

Literature: Wilton 1979, no.P116.; Armstrong 1902, p.232; Finberg 1961, no.163; Butlin and Joll, 1977, no.116.

Turner's composition, although fundamentally a topographical 'country-house portrait', is structured and lit with a considerable subtlety which belies this naturalism. Although the house itself does not occupy a prominent position on the canvas, it has been lit to attract attention as the eye is drawn through the receding groups of trees to the crest of the hill. Even Turner's handling of the sky contributes to this tunnel-like composition.

A careful pencil study for the painting appears in a sketchbook used by Turner in 1810 (CXXXVII, ff.3v., 4, Tate Gallery), during a visit to Sussex. Although the catalogue of the James Alexander sale of 1851 states that the picture was 'painted for Mr Alexander', he did not purchase the house until 1816. It is not known whether W. F. Woodgate, the owner of Somerhill in 1810, played any part in Turner's choice of subject.

Purchased at the Brocklebank sale, Christie's 7 July 1922 (71), (through Agnew) with funds from the Cowan Smith Bequest.

§2 The Vaughan Bequest of Turner Watercolours

Munro School Drawings

The first group of watercolours from the Vaughan Bequest must be placed in a category of drawings which bears an attribution to Turner but which forms part of a large body of work drawn by the young artists who worked under the patronage of Dr Thomas Monro (1759–1833) during the 1790s. (See introduction, p.9 above.)

Many of these 'Monro School' works are similar in media and subject matter. They are found in most collections of Turner's work. Attempts have been made, without much success, to assign particular examples to Turner or Girtin, both of whom adopted the familiar shorthand drawing style which figures so prominently in their work of this period. Finberg (1961, p.37), Turner's biographer and the cataloguer of the Turner Bequest, warned that 'among the 400 blue and grey drawings in the Turner Bequest … nearly 100 shipping subjects at Dover and Folkestone must now be regarded with suspicion'. Turner himself is known to have purchased several such watercolours at Dr Monro's sales in 1833, presumably to prevent them entering the market as his own work. Ironically, however, they were catalogued as such by his executors.

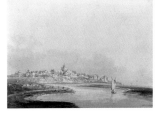

2

Rye, Sussex

D NG 853

Blue and grey washes over pencil on paper 19.6 × 26.9 cm

Literature: Armstrong 1902, p.275.

Henry Vaughan Bequest 1900

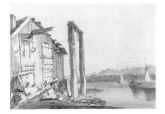

3

The Medway

D NG 854

Blue and grey washes over pencil on paper 20.6 × 29.7 cm

Literature: Armstrong 1902, p.266.

Henry Vaughan Bequest 1900

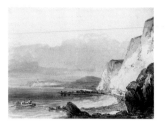

4

Beachy Head looking towards Newhaven

D NG 855

Blue and grey washes over pencil on paper
20.3 × 27.5 cm

Exhibited: R.A.1887 (12)

Literature: Armstrong 1902, p.241.

Henry Vaughan Bequest 1900

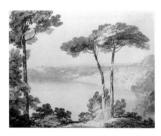

5

Lake Albano

D NG 882

Blue and grey washes over pencil on paper
42.2 × 54.7 cm
Inscribed on the verso *'Lake Albano or Nemi, Castel Gandolfo 31a'*.

Literature: Armstrong 1902, p.238.

D NG 882 is a copy, in reverse, of a watercolour attributed to J. R. Cozens in the City Art Gallery, Leeds (cat.846/28). A similar 'Monro Academy' *Lake Nemi*, also attributed to Turner, was exhibited at the Royal Academy Turner Exhibition in 1975 (cat.B23).

Henry Vaughan Bequest 1900

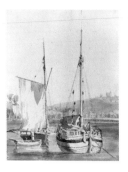

6

Old Dover Harbour

D NG 856

Blue and grey washes over pencil on paper
27.2 × 20.9 cm

Exhibited: R.A.1887 (10)

Literature: Armstrong 1902, p.249.

Henry Vaughan Bequest 1900

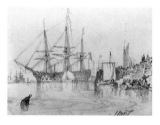

7

Man of War

D NG 852

Pencil on paper 16.1 × 22.6 cm

Signed: with initials bottom right

Literature: Dawson 1988, p.76; Warrell 1991, nos.76–7.

This is one of a group of four drawings of shipping subjects which Turner made in 1827 while at East Cowes. One of these, which also belonged to Vaughan and is now in the National Gallery of Ireland (cat.2401), is watermarked 'J. Whatman 1827'. The

remaining two are in a private collection. Unusually for pencil drawings on this scale, Turner signed them, apparently for presentation. Turner was fascinated by the sea and made countless studies of ships throughout his career. During the 1820s, projects such as the *Ports of England* and the *Marine Views* concentrated his attention on marine subjects such as this.

Henry Vaughan Bequest 1900

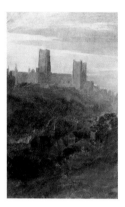

8

Durham

D NG 889

Watercolour over pencil on paper 40.9 × 25 cm
Watermark: J. Whatman / 1794

Literature: Wilton 1979, no.316; Armstrong 1902, p.251; Finberg 1909, vol.I, p.124; Dawson 1988, p.62.

Like D NG 886 (below), this view of Durham from the north-west is associated with the 1801 'Smaller Fonthill Sketchbook' (XLVIII, Tate Gallery). There are also two closely related watercolours in the 'Helmsley sketchbook' (LIII ff.97–8). There are two other related views of the city from this visit in the summer of 1801. One, of the castle, from the same spot, is at Leeds (City Art Gallery, cat.5.225/52). The other, in a private collection (Wilton 1979,

no.314), was drawn looking up towards the cathedral, a little upstream, beside the River Wear.

Another drawing from the same sketchbook, *Edinburgh from Salisbury Crags*, was in the group of drawings given by Vaughan to Dublin (cat.2140).

Henry Vaughan Bequest 1900

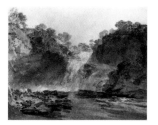

9

The Falls of Clyde

D NG 886

Watercolour over pencil with some scraping on two sheets of paper joined and laid down 41.3 × 52.1 cm
Watermark: J. Whatman / 1794

Literature: Wilton 1979, no.322; Armstrong 1902, p.247; Finberg 1909, vol.I, p.124; Dawson 1988, p.62.

As Finberg suggested, the sheets of paper used for this drawing (and D NG 889, above) agree closely in size and watermark with those in the 'Smaller Fonthill Sketchbook' (XLVIII, Tate Gallery) which Turner used on his tour to Scotland and the North of England in 1801. Other related drawings are in Cambridge, Mass. (Fogg Art Museum, cat.1907.9) and Indianapolis (Museum of Art). The drawings show Turner developing a new watercolour manner, more dramatic in its use of colour and the effects of light, and less concerned with topographical description. This is the earliest of Turner's depictions of *The Falls of Clyde*. He exhibited a watercolour based on his 1801 sketches at the Royal Academy in 1802 (no.336.

Walker Art Gallery, Liverpool, cat.864) and returned to the subject during the late 1830s in a canvas now at Port Sunlight (Lady Lever Art Gallery).

Henry Vaughan Bequest 1900

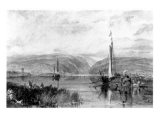

10

Neuwied and Weise Thurn, with Hoch's Monument on the Rhine, looking towards Andernach

D NG 857

Pen and ink and watercolour with some gum and scraping on paper 18.6 × 28.8 cm

Provenance: W. B. Cooke; James Slegg.

Exhibited: W. B. Cooke Gallery 1823, no.34; R.A.1892 (66).

Literature: Wilton 1979, no.689; Armstrong 1902, p.268; Finberg 1961, pp.256, 278, 484, no.282; Powell 1991, pp.36, 100.

Engraved: R. Brandard 1853 (Rawlinson, no.670).

In August and September 1817 Turner was able to make his first journey to the Continent since his visit to France and Switzerland during the Peace of Amiens in 1802. Like many artists and writers he wished to see the field of Waterloo, already celebrated by Byron, among others, in *Childe Harold*. After visiting Belgium he travelled up the Rhine as far as Mainz before returning to England through Holland. Most of the journey seems to have been made on foot. As he walked he made numerous pencil drawings, using a total of four sketchbooks throughout the tour (CLIX–CLXII, Tate Gallery). Many of these were later worked up into finished

drawings, including a group of fifty-one watercolours for which Walter Fawkes paid Turner £500. D NG 857 is very closely based on a drawing in the 'Waterloo and Rhine Sketchbook' (CLX, f.78v.–79r., Tate Gallery) which shows the town of Weissenthurm on the left of the view (the white tower after which it is named is seen in shadow) and Neuweid on the opposite bank. A slightly smaller version, dating from 1817, (one of the drawings purchased by Fawkes), is at Winchester College.

D NG 857 is one of three extant drawings more highly worked than the others which resulted from the 1817 tour. (The others are *Ehrenbreitstein*, Bury Art Gallery and Museum, and *Osterspey and Feltzen on the Rhine*, Museum of Art, Rhode Island School of Design, Providence, RI). It is probable that they were intended for the series of thirty-six engravings of Rhine views for which Turner signed a contract with W. B. Cooke in 1819. The scheme was abandoned after another Rhine series was published by Ackermann before the Turner set could be finished.

Henry Vaughan Bequest 1900

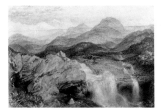

I I

Falls near the Source of the Jumna in the Himalayas

D NG 862

Watercolour with scraping on paper 13.6 × 20.2 cm

Exhibited: R.A.1892 (50).

Literature: Wilton 1979, no.1295; Armstrong 1902, p.259.

Engraved: J. Cousen 1836, for *Views of India, chiefly among the Himalaya Mountains* (Rawlinson no.610)

This is one of seven drawings by Turner based on sketches by Lieutenant George Francis White which were engraved for *Views of India, chiefly among the Himalaya Mountains*, published in full in 1838. Another, at Leeds, (City Art Gallery, cat. 594/25) shows *Part of the Ghaut at Hurdwar*.

Henry Vaughan Bequest 1900

I 2

Rhymer's Glen, Abbotsford

D NG 858

Watercolour with pen details and scraping on paper 14 × 9 cm

Provenance: Benjamin Godfrey Windus by 1840.

Exhibited: R.A.1892 (65).

Literature: Wilton 1979, no.1119; Armstrong 1902, p.273; Finley 1972, p.366, n.51; Finley 1980, pp.117–8, 208–9; Gage 1980, p.300.

Engraved: W Miller 1835, for *The Miscellaneous Prose Works of Sir Walter Scott* (Rawlinson, no.542)

The vignette, *Rhymer's Glen*, shows an area of woodland on the Abbotsford estate much loved by Scott for its picturesque appearance. Preliminary sketches appear on ff.49–51v. of the 'Edinburgh Sketchbook' and ff.4v., 5v., 6 of the 'Abbotsford Sketchbook' (CCLXVIII and CCLXVII, Tate Gallery), used by Turner on his visit to the Borders between 4 and 11 August 1831, while making preparations for the great project to illustrate Robert Cadell's edition of Scott's *Works*. Turner's determination to sketch the Glen in the company of Scott's daughters, after a good dinner at Chiefswood Cottage on August 7 1831, is recounted in the full notes of the artist's visit to Abbotsford kept by Cadell (now in the National Library of Scotland, MSS.21021, 21043). Sir Walter died on 21 September 1832, while Turner was in France, and the finished vignette, showing the author's walking stick left on a rustic bench (which is included in the drawing on f.50v of the 'Edinburgh Sketchbook') by the stream, is in part a tribute to the continued influence of his writing on Turner's own perceptions of the landscape.

D NG 858 was engraved as the title vignette for volume XXI of Cadell's *Works of Sir Walter Scott*, one of the volumes of *Periodical Criticism*, which includes Scott's critical writings on landscape gardening.

Henry Vaughan Bequest 1900

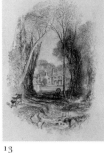

12 13

I 3

Chiefswood Cottage at Abbotsford

D NG 859

Watercolour with pen and ink details on paper 15 × 10 cm

Provenance: Benjamin Godfrey Windus by 1840.

Exhibited: R.A.1892 (55).

Literature: Wilton 1979, no.1118; Armstrong 1902, p.246; Finley 1980, pp.209–10; Gage 1980, p.300.

Engraved: W. Miller 1835, for *The Miscellaneous Prose Works of Sir Walter Scott* (Rawlinson, no.541)

Chiefswood Cottage, on the Abbotsford estate, was the summer home of John Gibson Lockhart and his wife Charlotte Sophia, Scott's daughter. Like D NG 858, this vignette is based on a pencil drawing in the 'Edinburgh Sketchbook' (CCLXVIII, f.52, Tate Gallery), used by Turner on his visit to Scotland in 1831 and worked up after Scott's death in 1832.

D NG 859 was engraved as the title vignette for volume XVIII of Cadell's *Works of Sir Walter Scott*, one of the volumes of *Periodical Criticism*. The empty chair under the trees may, as in *Rhymer's Glen*, be symbolic of the departed Scott. The unoccupied writing desk in the sun, facing the empty chair, is possibly a reference to Lockhart's projected *Memoirs of the Life of Sir Walter Scott*, the first of the ten volumes of which was not published by Cadell until 1836.

Henry Vaughan Bequest 1900

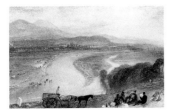

14

Melrose

D NG 860

Watercolour with scraping on paper 10 × 15.6 cm

Literature: Wilton 1979, no.1080; Armstrong 1902, p.266; Finberg 1961, p.492, no.375; Finley 1972, p.366, n.51, p.369; Finley 1980, pp.162–3.

Engraved: W. Miller 1833, for *The Lay of the Last Minstrel*, vol.VI of Sir Walter Scott's *Poetical Works* (Rawlinson, no.503)

The pencil drawing on which D NG 860 is based appears on ff.14v.–15 of the 'Abbotsford Sketchbook' (CCLXVII, Tate Gallery) used by Turner on his Borders journey in 1831. In his diary Robert Cadell describes two visits to this spot above the Tweed. On 6 August, on their way to and from Smailholm Tower, Scott, his servant, Turner and Cadell stopped to admire the view. On the following Monday evening (the day after Turner's nocturnal visit to Rhymer's Glen) the party returned, apparently without Scott, and had a picnic while Turner drew. The whole party, including Scott, can be seen in the foreground.

According to Cadell, Scott had given Turner the choice of the illustration for the frontispiece for *The Lay of the Last Minstrel* and it was to this view which the artist returned.

Henry Vaughan Bequest 1900

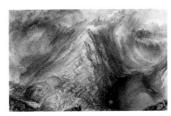

15

Loch Coruisk, Skye

D NG 861

Watercolour with scraping on paper 8.9 × 14.3 cm

Literature: Wilton 1979, no.1088; Armstrong 1902, p.248; Finley 1980, pp.137–8, 142, 243; Gage 1987, pp.220–1.

Engraved: H. le Keux 1834, for *The Lord of the Isles*, vol.X of Sir Walter Scott's *Poetical Works* (Rawlinson, no.511)

After Turner left the Borders on his 1831 tour of Scotland, he visited Edinburgh and made final preparations with Cadell for a journey to the Highlands which he undertook alone. The artist and publisher had agreed a list of suitable subjects for the illustration of Scott's *The Lady of the Lake* and *The Lord of the Isles* and Turner was determined to reach both Fingal's Cave and the remote and inaccessible Loch Coriskin (Coruisk) on Skye. Although there are a number of pencil drawings made after the spectacular climb from the loch-shore in the 'Stirling and the West Sketchbook' (CCLXX, Tate Gallery, e.g. f.38v.), none relate directly to this magnificent watercolour.

Published as the frontispiece to Cadell's edition of *The Lord of the Isles*, the great whirling vortex of this meteorological and geological *tour de force* is one of the finest of Turner's small-scale illustrative works. The extent to which his ideas had developed in this direction can well be seen in a very similar composition, his *Liber Studiorum* plate of *Ben Arthur* of 1819 (Finberg no.69).

Henry Vaughan Bequest 1900

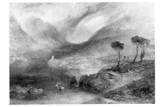

16

Llanberis Lake and Snowdon – Caernarvon, Wales

D NG 884

Watercolour, bodycolour, with pen and ink details on paper 31.8 × 47.1 cm
Inscribed: on the verso *Llanberis Lake*
Watermark: EDMONDS (and Pine ?) / 1829

Provenance: Charles Heath, 1833; G.B. Windus; purchased Vaughan 1854.

Exhibited: Moon, Boys and Graves Gallery, 1833, no.76; Manchester 1857.

Literature: Wilton 1979, no.855; Armstrong 1902, p.262; Finberg 1961, p.496, no.438; Shanes 1979, p.43, no.64; Wilton 1980, p.181, cat.110; Herrmann, 1990, p.133.

Engraved: J. T. Willmore, 1832 and published 1834 in *Picturesque Views in England and Wales* Part XVIII, no.3. (Rawlinson, no.279)

Both D NG 884 and D NG 883 (below), which are among Turner's most highly-finished British views, were painted to be engraved for the series of plates, *Picturesque Views in England and Wales*, initially commissioned by the publisher Charles Heath. The first print appeared in 1826 and during the following ten years the project passed through several publishers' hands. Heath himself was bankrupted by the series' commercial failure. It was to be in a serial form, and to consist of one hundred and twenty engravings issued in twenty-four parts. Many of the plates, including the *Llanberis* and *Durham* were based on much earlier sketches. Several drawings closely connected with *Llanberis* are in the 'Dolbadarn Sketchbook' (e.g. ff.21, 44, 98v., XLVI, Tate Gallery), datable to 1799.

Henry Vaughan Bequest 1900

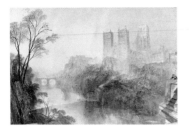

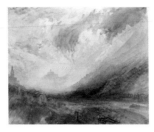

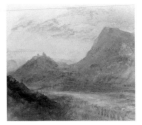

17

Durham

D NG 883

Watercolour, some gum and scraping on paper
29.5 × 44 cm

Literature: Wilton 1979, no.873; Armstrong 1902,
p.251; Shanes 1979, p.47, no.80; Herrmann, 1990,
p.136.

Exhibited: Manchester 1857; R.A.1887 (70).

Engraved: W. Miller, 1836 and published 1837 in
Picturesque Views in England and Wales Part XXIII, no.1.
(Rawlinson, no.297)

The first drawings to which Turner returned for
this design are to be found in the 'Helmsley
Sketchbook' (LIII, ff.16, 20, 22, Tate Gallery) of
1801. Another more elaborate study is in
(CCCLXIV, f.406). Turner apparently took
particular care over the corrections to proofs of
the resulting print, which is one of the finest in
the series.

Henry Vaughan Bequest 1900

18

Sion, Capital of the Canton Valais

D NG 864

Watercolour and bodycolour on paper 24.1 × 30 cm
Watermark: C. ANSELL / 1828

Exhibited: R.A.1892 (50).

Literature: Wilton 1979, no.1447; Armstrong 1902,
p.277.

Although a number of Turner's drawings are
associated with Sion, there are no pages in the
sketchbooks that can be positively identified as
having been made on the spot there. The only
sketchbook related by Ruskin to a visit to Sion
(CCCXXXVII, Tate Gallery) has been dismissed
since Finberg (1909, vol.II, p.1061) as spurious.
The dating and, indeed, identification of all
Turner's views of Sion is therefore highly
problematical. On stylistic grounds the present
drawing and D NG 876 (below), which possibly
also represents the same place, would seem to
belong to the mid-1830s. Turner was in
Switzerland in 1836 and was recorded by his
companion, Hugh Munro of Novar, as having
made watercolour sketches while there. The
following group of drawings may well date from
the period of that tour or shortly after.

Henry Vaughan Bequest 1900

19

Sion, Rhône (or Splügen)

D NG 876

Watercolour and scraping on paper 24.5 × 27.7 cm

Literature: Wilton 1979, no.1446; Armstrong 1902,
p.279.

The actual location featured in this drawing is
open to doubt (see D NG 864, above). It was
formerly identified as a view of Splügen
although the topography would seem to relate
more closely to the Rhône valley. It may simply
be one of Turner's 'colour beginnings', with no
specific topographical significance. The
drawing would appear to date from the same
period as D NG 864.

Henry Vaughan Bequest 1900

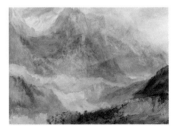

20

Monte Rosa
(or *the Mythen, near Schwytz*)

D NG 887

Watercolour on paper 24.3 × 33.9 cm

Literature: Wilton 1979, no.1433; Armstrong 1902,
p.274; Cormack 1975, p.62, no.35.

Although nothing in Turner's extant sketchbooks relates exactly to this composition, the drawing appears to date from about the period of his 1836 journey to France and Switzerland. Two drawings in the 'Lake Thun Sketchbook' used much earlier, in 1802, (LXXVI, ff.43, 44, Tate Gallery) identified by Finberg as the Mythen, near Schwytz, seem to represent the same mountain view. A watercolour at Cambridge (Fitzwilliam Museum reg.1612) dating from the mid-1830s may also be related.

Henry Vaughan Bequest 1900

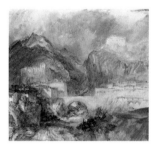

21

Verrès in the Val d'Aosta

D NG 865

Watercolour, pen and red ink and scraping out on paper 25.6 × 27.8 cm

Literature: Wilton 1979, no.1435; Armstrong 1902, p.240; Finberg 1961, p.361; Cormack 1975, p.62, no.35; Boase 1956, p.289.

Several rather slight sketches in the 'Fort Bard Sketchbook' (CCXCIV, Tate Gallery), used by Turner on his 1836 tour, are of Verrès. Two, ff.50–51 relate closely to this drawing. The pen and ink working of D NG 865 itself, however, is typical of a manner of drawing adopted by the artist only at the end of the 1830s and it may be that the drawing was worked up long after the tour.

Henry Vaughan Bequest 1900

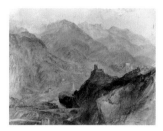

22

Chatel Argent, in the Val d'Aosta, near Villeneuve

D NG 870

Watercolour, bodycolour and scraping on paper 24 × 30.2 cm

Literature: Wilton 1979, no.1434; Armstrong 1902, p.239; Boase 1956, p.289; Finberg 1961, p.361; Cormack 1975, p.62, no.35; Dawson 1988, p.100.

The watercolour was entitled *Among the Italian Alps* when it entered the Gallery's collection. A number of sketches in the 'Fort Bard Sketchbook' (CCXCIV, Tate Gallery) of 1836 were made in the vicinity of Chatel Argent, the closest to D NG 870 being f.83 and f.85. Another of Vaughan's watercolours now in Dublin (cat.2146), probably shows the same location but from a different viewpoint.

Henry Vaughan Bequest 1900

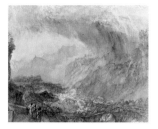

23

The St Gothard Pass at the Devil's Bridge

D NG 877

Pencil and watercolour and scraping on paper 23.2 × 28.9 cm

Watermark: J. WHATMAN / TURKEY MILL.

Literature: Wilton 1979, no.1497; Armstrong 1902, p.255.

Turner crossed the St Gothard Pass in 1802 and then not again until the 1840s. Most of his studies of the Pass showing the Devil's Bridge appear in the 'St. Gothard and Mont Blanc' and 'Lake Thun' sketchbooks used in 1802 (LXXV and LXXVI e.g. f.73, Tate Gallery). Although it is possible that the watercolour might date from the 1830s, based on a sketch from Turner's first Swiss journey, the style and dimensions of the drawing would seem to be consistent with several others which the artist produced during the early 1840s after returning to that area (e.g. Fitzwilliam Museum, Cambridge, reg.586–7).

Henry Vaughan Bequest 1900

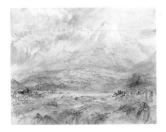

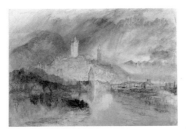

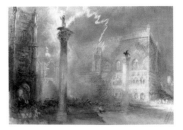

24

Schwyz

D NG 863

Watercolour over traces of black chalk with touches of pen and brown ink on paper 22.6 × 28.8 cm
Watermark: J. WHATMAN / TURKEY MILL 18[11?].

Literature: Wilton 1979, no.1487; Armstrong 1902, p.276.

Turner visited Switzerland six times; his first journey, in 1802, followed the Peace of Amiens. Apart from one visit with a diversion to Lake Geneva in 1836, Turner's major Swiss tours followed in successive years between 1841 and 1844. A sketchbook, 'Lake of Zug and Goldau' (CCCXXXI, Tate Gallery), now dated to 1843, contains pencil sketches (ff.12v., 23, 23v.) related to D NG 863.

Henry Vaughan Bequest 1900

25

Thun

D NG 866

Watercolour over black chalk with touches of pen and ink and scraping on paper 24.9 × 36.4 cm

Literature: Wilton 1979, no.1504; Armstrong 1902, p.280.

Stylistically this watercolour can be dated to the 1840s. It bears similarities to coloured drawings such as those in the 'Thun and Interlaken Sketchbook' (CCCXLVI, Tate Gallery), used on Turner's 1844 trip to Switzerland. The town and lake of Thun are the subjects of many compositions by Turner and appear on one of the plates for the *Liber Studiorum.*

Henry Vaughan Bequest 1900

26

The Piazzetta, Venice

D NG 871

Watercolour and bodycolour with pen and ink and scraping on paper 22.1 × 32.1 cm
Watermark: J. WHATMAN / 1834.

Literature: Wilton 1979, no.1352; Armstrong 1902, p.282; Finberg 1961, p.355.

Turner visited Venice on three occasions, in 1819, 1833 and 1840. There are about one hundred and seventy extant watercolour views of the city, of which Vaughan owned nine. Six of these are now in Edinburgh, three in Dublin.

The watermark of this drawing indicates that it probably dates from between the 1833 and 1840 visits, although Turner also used identical paper during the latter journey (see below, D NG 872). During these years Turner produced a number of watercolours of Venetian subjects, often with fireworks, storms and other forms of dramatic lighting. A group of these (e.g. CCCXIX, Tate Gallery) are in bodycolour on brown paper. Here, however, the lightning effect is created by scraping out and rubbing into the surface of white paper. These drawings appear to be connected with the development of Turner's great canvas *St Mark's Place, Venice: Juliet and her Nurse,* exhibited at the Royal Academy in 1836 (no.73, now in a Private Collection, New York).

Henry Vaughan Bequest 1900

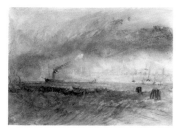

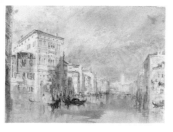

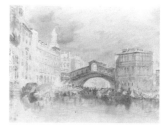

27

Venice from the Laguna

D NG 872

Watercolour, pen and ink and scraping on paper
22.1 × 32 cm

Watermark: J. WHATMAN / 1834

Literature: Wilton 1979, no.1371; Armstrong 1902, p.282.

Although it is almost impossible to establish precisely which works were executed in Venice and which date from after Turner's return to England, the following group of Venetian drawings appears to correspond closely with others which can be dated to the period of the 1840 visit.

Although their common watermark and paper size might suggest that D NG 872 and D NG 871 (above) were part of the same sketchbook and might share a common date, the present drawing almost certainly comes from a sketchbook roll of identical paper used on Turner's visit to Venice in 1840 (CCCXV, Tate Gallery). The mood and tone of the drawing, an open view over water, is also more characteristic of this later stay than of the earlier, when Turner's watercolours had often explored more markedly theatrical themes.

Henry Vaughan Bequest 1900

28

The Palazzo Balbi on the Grand Canal, Venice

D NG 873

Watercolour and bodycolour over black chalk
23.1 × 30.7 cm

Exhibited: R.A.1892 (53).

Literature: Wilton 1979, no.1372; Armstrong 1902, p.282.

A group of Venetian subjects in the Turner Bequest shows a similar interest in the white marble facades and red tiled roofs of Venetian palazzi. A slightly wider angle version of this view appears on f.20 of roll sketchbook CCCXV (Tate Gallery), which almost certainly dates from about 1840.

Henry Vaughan Bequest 1900

29

The Rialto, Venice

D NG 874

Watercolour over black chalk 22.7 × 30.2 cm

Exhibited: R.A.1892 (54).

Literature: Wilton 1979, no.1369; Armstrong 1902, p.282.

A very similar view of the Rialto, from the other side of the bridge, appears on f.2 of roll sketchbook CCCXV. (See note to D NG 873, above.)

Henry Vaughan Bequest 1900

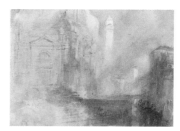

30

The Grand Canal by the Salute, Venice

D NG 888

Watercolour, bodycolour and pen and ink on paper
22.2 × 32.2 cm

Exhibited: R.A.1892 (66).

Literature: Wilton 1979, no.1370; Armstrong 1902, p.282.

This atmospheric drawing seems to be characteristic of Turner's 1840 visit to Venice.

Henry Vaughan Bequest 1900

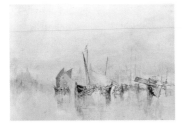

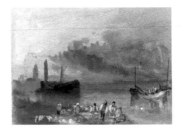

31

The Sun of Venice

D NG 875

Watercolour on paper 21.90 × 32.00 cm

Literature: Wilton 1979, no.1374; Armstrong 1902, p.282.

The title of the drawing refers to the emblem on the sail of the leading fishing boat. Turner was always particularly interested in the sea and in boats of all descriptions; his view of the *Laguna* (D NG 872, above) shows a steam-boat billowing smoke against a stormy Venetian sky. A group of studies of various small craft appears in the 'Venice Sketchbook' of 1840 (CCCXIV, Tate Gallery). Turner's oil painting of *The Sun of Venice going to Sea* was exhibited at the Royal Academy in 1843 (no.129, now in the Tate Gallery).

Henry Vaughan Bequest 1900

32

Harbour View

D NG 880

Bodycolour on blue paper 13.9 × 18.9 cm

Literature: Wilton 1979, no.921; Armstrong 1902, p.256.

There is a large group of paintings in gouache on blue paper which Turner produced over a period of years. The earliest seem to be those made at Petworth from the mid-1820s. This drawing and D NG 881 (below) may possibly date from this period.

Whereas Turner had used bodycolour on tinted surfaces on many previous occasions, notably at Farnley (a further example in the National Gallery of Scotland is the *Caley Hall* of 1817 in the Barlow Bequest, cat. 64), in the blue paper studies he achieved a remarkable intensity of colour which was reflected later on in the vignette illustrations which were made to be engraved. He continued to use this blue paper technique as late as 1839 (see D NG 879, below).

Henry Vaughan Bequest 1900

33

Sea View

D NG 881

Bodycolour on blue paper 13.5 × 19 cm

Literature: Wilton 1979, no.922; Armstrong 1902, p.277.

See note to D NG 880

Henry Vaughan Bequest 1900

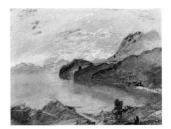

34

Lake Como looking towards Lecco

D NG 878

Bodycolour on blue paper 14.2 × 18.8 cm

Literature: Wilton 1979, no.1038; Armstrong 1902, p.247.

None of Turner's sketches has been related directly to this drawing which would seem to date from the late 1820s. There is a sketchbook of the area (CLXXIV, Tate Gallery) dating from 1819.

Henry Vaughan Bequest 1900

35

Ehrenbreitstein from the Mosel

D NG 879

Bodycolour on blue paper 13.8 × 18.9 cm

Literature: Wilton 1979, no.1034; Armstrong 1902, p.252; Powell 1991, p.149.

D NG 879 follows closely a pencil drawing in the 'Cochem to Coblenz' sketchbook (CCXCI, Tate Gallery) made on Turner's second Mosel tour in 1839. The present sheet is the final view in the great series of blue-paper gouaches in the Turner Bequest, showing the River Mosel from Trier to the junction with the Rhine at Coblenz. The series was never engraved or published and this is one of the very few of these drawings to have left the artist's possession.

Henry Vaughan Bequest 1900

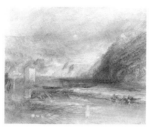

36

Falls of the Rhine at Schaffhausen, Front View

D NG 867

Watercolour, bodycolour, pen and ink detail and scraping on paper 23.1 × 28.8 cm

Provenance: Possibly purchased from Turner by Charles Stokes; by inheritance to Hannah Cooper, 1853.

Literature: Wilton 1979, no.1464; Armstrong 1902, p.276; Herrmann 1970.

The inscribed date, *1841*, on D NG 869 has also been accepted for D NG 868 and this drawing. Turner had first visited the falls at Schaffhausen, on the Rhine, in 1802. The 'Fonthill Sketchbook' of 1799–1802 includes several pencil drawings (XLVII, ff.29–31, Tate Gallery) and there is also a further group of more substantial watercolours dating from the same year (LXXIX, ff.A–E, Tate Gallery). Turner exhibited a canvas at the Royal Academy in 1806 (no.182. now at Boston, Museum of Fine Arts, no.13.2723). Although no further studies of the falls are recorded in Turner's extant sketchbooks, it has been suggested that these drawings may possibly be sheets removed from the 'Fribourg, Lausanne and Geneva' volume (CCCXXXII, Tate Gallery), used on his Swiss tour of 1841.

A number of other drawings which stylistically are clearly closely related include those at the Courtauld Institute of Art (no.12.74) and Cambridge (Fitzwilliam Museum, reg.583). The technique of these studies follows a system which Turner had used on earlier occasions; that of preparing his paper with a wash of grey colour on to which he floated his subject before rubbing and scraping into the surface of the paper to create the effects of spray and highlights.

This group of drawings is rare among the sheets in the Vaughan Bequest in having an early provenance. They appear to be the watercolours identified in a notebook written by Hannah Cooper, now in the Indianapolis Museum of Art.

Henry Vaughan Bequest 1900

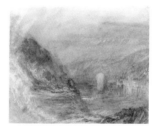

37

Falls of the Rhine at Schaffhausen, Side View

D NG 868

Watercolour, bodycolour, pen and ink detail and scraping on paper 23 × 28.6 cm

Provenance: Possibly purchased from Turner by Charles Stokes; by inheritance to Hannah Cooper, 1853.

Literature: Wilton 1979, no.1463; Armstrong 1902, p.276; Herrmann 1970.

See note to D NG 867.

Henry Vaughan Bequest 1900

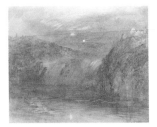

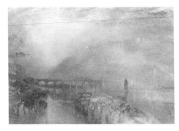

38

Falls of the Rhine at Schaffhausen,
Moonlight

D NG 869

Watercolour, bodycolour, pen and ink details and
scraping on paper 22.9 × 28.5 cm
Inscribed: *Falls of the Rhein / 1841*

Provenance: Possibly purchased from Turner by
Charles Stokes; by inheritance to Hannah Cooper,
1853.

Literature: Wilton 1979, no.1460; Armstrong 1902,
p.276; Herrmann 1970.

See note to D NG 867

Henry Vaughan Bequest 1900

39

Heidelberg

D NG 885

Watercolour, pen and ink and scraping out on paper
37.4 × 55.3 cm
Literature: Wilton 1979, no.1554. p.244–5;
Armstrong 1902, p.257.

A number of large views of Heidelberg dating
from the early 1840s can be connected with
preliminary drawings made on tours during
those years (e.g. CCCLXV f.34, dated *10 Mar 41*,
Tate Gallery). A drawing, very similar in
composition to D NG 885, but closer in style to
Turner's work at the beginning of the decade, is
in Manchester (City Art Gallery, reg.1917.106).
Another, of the same view but differing in
detail, is in a Scottish private collection and was
engraved by T. A. Prior in 1846 (Rawlinson
no.663). The looser treatment of detail such as
the figures and the buildings in the town
suggest that D NG 885, one of the artist's finest
late drawings, may well date from about 1846.

Henry Vaughan Bequest 1900

§3 Turner's Illustrations to The Poetical Works of Thomas Campbell

The twenty illustrations to Campbell's poems were accepted by H. M. Treasury in lieu of inheritance tax on the estate of Mrs M. D. Fergusson and allocated to the National Gallery of Scotland in 1988.

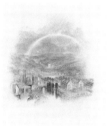

40

At Summer Eve (Illustration to The Pleasures of Hope)

D 5153

Watercolour over pencil on paper 13 × 12.5 cm
Signed: in watercolour, bottom right, *JMW Turner RA*

Literature: Wilton 1979, no.1271; Armstrong 1902, p.272.

Engraved: E. Goodall (Rawlinson no.613).

Campbell wrote *The Pleasures of Hope* at the age of 18, in 1795, while teaching on Mull. On publication in 1799 it was an instant success. This, and the next three illustrations (D 5154, D 5155 and D 5156) evoke in turn, the hope lent to the future by the 'enchantment' of its distance from the present; the charms sung by Hope, the guiding star to those in peril; the utter despair felt when even Hope has 'bade the world farewell'; and finally the hope offered by God.

41

The Andes (Illustration to The Pleasures of Hope)

D 5154

Watercolour over pencil on paper 11.5 × 11.5 cm
Signed: in watercolour, bottom right, *JMW Turner RA*

Literature: Wilton 1979, no.1272; Armstrong 1902, p.239.

Engraved: E. Goodall (Rawlinson no.614).

See note to D 5153.

42

Kosciusko (Illustration to The Pleasures of Hope)

D 5155

Watercolour over pencil on paper 11.5 × 11.2 cm
Inscribed: *KOSCISKO* in watercolour, bottom right, and below *The sun went down, nor ceased the carn*[age] *there / &c / Pleasures of Hope.*

Literature: Wilton 1979, no.1273; Armstrong 1902, p.260.

Engraved: E. Goodall (Rawlinson no.615).

Tadeusz Kosciuszko (1746–1814) was a Polish soldier and statesman whose colourful career took him to Pennsylvania to fight for American Independence during the 1770s, before returning to fight for the freedom of his native country against the Russians. In March 1794 he led an uprising which culminated in a two-month siege of Warsaw by Russian and Prussian forces. It is this event, news of which was still fresh in his memory, which Campbell is describing in the poem. The events of the 1790s had an unhappy parallel in 1830, shortly before Turner came to illustrate the poem, when another rising against Russian domination was unsuccessful. See also note to D 5153.

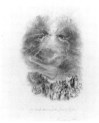

43

Sinai's Thunder (Illustration to The Pleasures of Hope)

D 5156

Watercolour over pencil on paper 12.5 × 9.5 cm
Inscribed: *Like Sinai's thunder, pealing from the cloud / Pleasures of Hope.*

Literature: Wilton 1979, no.1274; Armstrong 1902, p.277; Wilton 1980, p.140, cat.53; Lyles and Perkins 1989, p.77, cat.82.

Engraved: R. Wallis (Rawlinson no.616).

See note to D 5153.

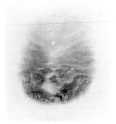

44
A Swiss Valley: Theodric

D 5157

Watercolour over pencil on paper 13.5 × 11.5 cm

Inscribed: *Twas sunset, / &c / Theodric.* Also inscribed lower centre (on stone) *JULIA.*

Literature: Wilton 1979, no.1275; Armstrong 1902, p.279.

Engraved: E. Goodall (Rawlinson no.617).

The opening lines of *Theodric* describe sunset in the Swiss Alps. The narrator of the poem, standing beside Julia's rose-covered tombstone in the graveyard of a gothic church is told the story of her ill-starred love for a soldier, Theodric.

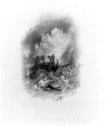

45
O'Connor's Child

D 5158

Watercolour over pencil on paper 12.5 × 9 cm

Inscribed: *A bolt that overhung our dome / &c / O'Connor's Child.*

Literature: Wilton 1979, no.1276; Armstrong 1902, p.269.

Engraved: E. Goodall (Rawlinson no.618).

Turner's vignette shows Campbell's heroine sending her brothers to their deaths in battle against the English. They have killed her lover Connocht Moran and in revenge she brings about the destruction of Castle Connor and her clan.

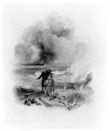

46
Lochiel's Warning

D 5159

Watercolour over pencil on paper 14.5 × 12.5 cm

Literature: Wilton 1979, no.1277; Armstrong 1902, p.262.

Engraved: E. Goodall (Rawlinson no.619).

The 'gentle' but heedless Lochiel is confronted by a 'Wizard' who foretells the horrors of Culloden and its aftermath. Turner illustrates several stanzas of the dialogue; behind the executioner's block is the battle itself, to the right a riderless horse returns to a bereaved bride.

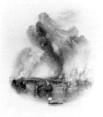

47
Battle of the Baltic

D 5160

Watercolour over pencil on paper 14 × 13 cm

Literature: Wilton 1979, no.1278; Armstrong 1902, p.241.

Exhibited: Royal Academy 1974, cat.293.

Engraved: E. Goodall (Rawlinson no.620).

Campbell had witnessed the preparations for the Battle of Copenhagen in April 1801. His description of the ships 'like Leviathans afloat' and of the gunfire which 'spread a death-shade round the ships / Like a hurricane eclipse / of the sun' would have greatly appealed to Turner who visited Heligoland on his tour of the continent in 1835. The vignette illustrates the opening lines of the poem; 'Of Nelson and the North / Sing the glorious day's renown, / When to battle fierce came forth / All the might of Denmark's crown'.

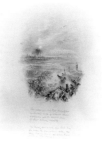

48
Hohenlinden

D 5161

Watercolour over pencil on paper 13.5 × 10 cm

Inscribed: *But redder yet that light shall glow / on Linden's – hills of stained snow / And bloodier yet the torrent flow / of Iser rolling rapidly / Tis Morn, but scarce yon level sun / Can pierce the war-clouds rolling dun / Where furious Frank and fiery Hun / Shouts in their sulphrous canopy.*

Literature: Wilton 1979, no.1279; Armstrong 1902, p.258.

Engraved: R. Wallis (Rawlinson no.621).

Campbell visited Hohenlinden very shortly after the battle there in December 1800. The poem contains much colourful imagery of a bloody battle fought in snow under a winter sun shrouded in acrid smoke. Like the vignette illustrating the *Battle of the Baltic* (cat.47), Turner based his image on sketches made on the spot during the summer of 1835.

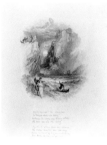

49

Lord Ullin's Daughter

D 5162

Watercolour over pencil on paper 12 × 10 cm
Inscribed: *and by my word! the bonnie bird / In danger shall not tarry / So though the waves are raging white / I'll row you oe'r the ferry / By this the storm grew loud apace / The water wraith was shrieking / and in the scowl of heaven each face / Grew dark as they were speaking / Lord Ullin's Daughter.*

Literature: Wilton 1979, no.1280; Armstrong 1902, p.262; Herrmann 1990, p.217.

Engraved: E. Goodall (Rawlinson no.622).

Campbell wrote his first draft for the poem while still a young man living at Lochgilphead. Turner shows Lord Ullin approaching the summit of a cliff beneath which his eloping daughter and her lover are awaiting the ferry. As they escape the boat capsizes in the storm leaving Lord Ullin to lament his wrath.

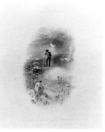

50

The Soldier's Dream

D 5163

Watercolour over pencil on paper 11.5 × 8 cm
Inscribed: *Soldier's Dream* and *I dremt* [sic] *of the pleasant fields traversed so oft / In life's morning march when my bosom was young.*

Literature: Wilton 1979, no.1281; Armstrong 1902, p.278; Herrmann 1990, p.218.

Engraved: E. Goodall (Rawlinson no.623).

Campbell's soldier lies on his pallet, his comrades around him dying or sleeping. Turner's soldier, on the other hand, stands resting on his musket, thus echoing the composition in the lower half of the picture where his dream of family and home in the countryside is depicted.

51

The Last Man

D 5164

Watercolour over pencil on paper 12.5 × 9 cm
Inscribed: *The last Man* and *Evn I am weary in you skies /*

To watch the fading fire / Test of all sumless agonies / Behold not me expire.

Literature: Wilton 1979, no.1282; Armstrong 1902, p.261.

Engraved: E. Goodall (Rawlinson no.624).

Perhaps the most unusual of the illustrations, the poet has a vision of the dying words of the last man alive on earth. The man apostrophizes the waning sun. His immortal soul, symbolised by the cross in the sky (Turner's own invention), will outlast even the power of nature.

52

The Valley (Illustration to Gertrude of Wyoming)

D 5165

Watercolour over pencil on paper 14 × 11 cm

Literature: Wilton 1979, no.1283; Armstrong 1902, p.286.

Engraved: E. Goodall (Rawlinson no.625).

The story of the massacre of European settlers which took place in Wyoming in 1778 provided Campbell with the setting for this poem. In his two illustrations to the poem Turner concentrates on the pastoral elements in the story. He shows the return of Henry Waldegrave, Gertrude's childhood sweetheart. In *The Waterfall* (D 5166, below) Turner depicts an imaginary earthly paradise in which even the young Gertrude can safely wander and sit reading Shakespeare among 'rocks sublime' and 'yellow lichen'.

53

The Waterfall (Illustration to Gertrude of Wyoming*)*

D 5166

Watercolour over pencil on paper 13 × 11.5 cm
Inscribed: *It was in this lone Valey* [sic] *she would charm / The lingering noon where flowers a couch had strewn / Gertrude of Wyoming.*

Literature: Wilton 1979, no.1284; Armstrong 1902, p.286.

Engraved: E. Goodall (Rawlinson no.626).

See note to D 5165.

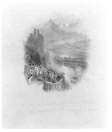

54

The Brave Roland

D 5167

Watercolour over pencil on paper 12 × 11.5 cm
Inscribed: *The Brave Roland* and *But why so rash has she taken the veil / In yon Nonenwerden's cloister, pale // Ther[e]'s one window yet of that pile / He built above the nun's green isle / When the chant and organ sounded slow / On the mansion of his love below / For herself he might not see.*

Literature: Wilton 1979, no.1285; Armstrong 1902, p.274; Powell 1991, p.117, cat.29.

Engraved: E. Goodall (Rawlinson no.627).

Campbell visited the Drachenfels in 1820. He was deeply moved by the view and by the experience of reading the *Song of Roland* on this dramatic spot. Turner has set the moment in Campbell's own poem when Aude, in despair at rumours of Roland's death, enters a nunnery. As she takes the veil Roland's horn is heard. Although Turner had made sketches on his visits to Rolandseck, there are none which show this view which sets the events against the backdrop of the Drachenfels and the tower which Roland was supposed to have built after Aude died so that he could look out into the convent from the lighted window.

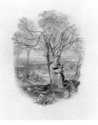

55

The Beech Tree's Petition

D 5168

Watercolour over pencil on paper 13.5 × 11 cm
Inscribed: *The Beech Tree's Petition* and *Carved many a long forgotten name / Spare woodman spare the Beechen Tree.*

Literature: Wilton 1979, no.1286; Armstrong 1902, p.242; Herrmann 1990, p.217.

Engraved: E. Goodall (Rawlinson no.628).

Ruskin particularly admired Turner's tree with its strong shadows across the trunk. Even this rustic scene is given a curiously heroic twist by the artist who has inscribed the name 'Roland', which does not appear in the poem, on the tree.

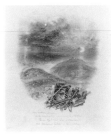

56

On Camp Hill, near Hastings

D 5169

Watercolour over pencil on paper 15 × 12.5 cm
Inscribed: *Over hauberk and helm / As the sun's setting splendour was thrown / Thence th[e]y looked o'er a realm / And tomorrow beheld it their own.*

Literature: Wilton 1979, no.1287; Armstrong 1902, p.257; Lyles and Perkins 1989, p.77, cat.83.

Exhibited: Royal Academy 1974, cat.294.

Engraved: E. Goodall (Rawlinson no.629).

'In the deep blue of even' the poet has climbed to the summit of Camp Hill from where he imagines the scene of the night before the Battle of Hastings. The blood of Norman chivalry would 'ennoble' England's breed after the battle.

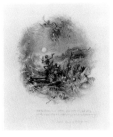

57

The Death Boat of Heligoland

D 5170

Watercolour over pencil on paper 13 × 12 cm
Inscribed: *But her beams on a sudden grew sick-like and grey / And the mews that had slept clangd and shrieked far away / The Death Boat of Heligoland.*

Literature: Wilton 1979, no.1288; Armstrong 1902, p.257.

Engraved: E. Goodall (Rawlinson no.630).

Turner's fascination with the sea is given full rein by Campbell's description of a crew of ghostly oarsmen encountered by a steersman in a storm off Heligoland. They cry that they are 'bound from our grave in the west'. The hovering spirits are Turner's own invention.

58

Ode to the Germans: Ehrenbreitstein

D 5171

Watercolour over pencil on paper 13.5 × 11.5 cm
Inscribed: *Whilst your Broad Stone of Honour / ode to the Germans.*

Literature: Wilton 1979, no.1289; Armstrong 1902, p.252.

Engraved: E. Goodall (Rawlinson no.631).

Campbell's invocation to German national pride and liberty celebrates that country, with doubtful accuracy, as the inventor of gunpowder, clock-making and printing. Turner depicts, as a symbol of German nationalism, the fortress of Ehrenbreitstein near Coblenz, (see also D NG 879, cat.35, above) the name of which appears in the poem translated as 'Broad Stone of Honour'.

59

The Dead Eagle

D 5172

Watercolour over pencil on paper 12 × 10 cm
Inscribed: *Fallen as he is, this king of birds still seems / Like royalty in ruins. / Though his eyes Are shut that looked / undazzled on the sun / He was the sultan of the sky / The dead Eagle.*

Literature: Wilton 1979, no.1290; Armstrong 1902, p.251.

Engraved: W. Millar (Rawlinson no.632).

Campbell's poem was inspired by a visit to North Africa in 1836, 'fresh from the luxuries of polished life / the echo of these wilds enchanted me'. While alive, the eagle soared over everything, even the forces of Nature. Turner has responded to these heroic elements in the poem which, however, ends with a colourful description 'of pastoral pleasantness'.

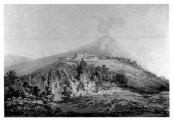

60

§4 Other Drawings by Turner

60

Vesuvius and the Convent of San Salvatore

D 5023.42

Blue, grey and brown washes over black chalk on paper 32.2 × 49 cm

Provenance: Dr. Bayley, Hereford (according to an inscription on the mount); Sir Thomas Barlow.

Literature: Andrews 1979, cat.45.

This drawing appears to be a 'Monro School' copy similar to those made by Turner after J. R. Cozens (see also D NG 882, cat.5, above). Although there are views of the Vesuvius area in the Cozens sketchbooks now in Manchester (Whitworth Art Gallery), none of these correspond to our drawing. It is, however, possible that Cozens also made a number of independent studies on larger sheets of paper, and that one of these provided the prototype of our drawing.

Miss Helen Barlow Bequest 1976

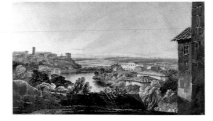

61

Rome: The Tiber with the Aventine on the Left

D 5023.55

Blue and brown washes with traces of black chalk on paper 27.5 × 48.5 cm
Inscribed: on the verso *no.25*.

Provenance: Dr. Thomas Barlow

Literature: Andrews 1979, cat.44.

Like D 5023.42 this is a 'Monro School' drawing, possibly after J. R. Cozens. No prototype by Cozens of this particular view is known.

Miss Helen Barlow Bequest 1976

62

Mount Snowdon, Afterglow

D 5284

Watercolour and some scraping out on paper
52.7 × 75.6 cm

Provenance: Sir Francis Seymour Hayden; Mr Holloway (as *Moon rising over Snowdon*); William Leech 1864; Rev. W. Macgregor 1887; Sold Christie's, April 23 1937, (8); Frost & Reid Ltd; B. Figgis 1941; Mrs Peggy Parker, by descent.

Exhibited: R.A.1886 (25); Guildhall 1898 (107); Franco-British exhibition 1908 (493); Thos. Agnew & Sons 1913, (8).

Literature: Armstrong 1902, p.278.

Turner first visited the mountains of North Wales in 1798 and 1799. This watercolour was probably painted very shortly afterwards. It is similar in style to other views of these mountains made at the same period. Although it does not appear to have been exhibited during Turner's lifetime, *Snowdon* was almost certainly intended as a 'finished' work for display. The drawing was exhibited several times during the late nineteenth century and was apparently well known until about fifty years ago. Since then it has not been recorded in the extensive literature on Turner's watercolours.

Mrs Peggy Parker Gift 1991

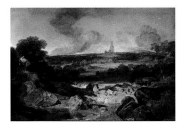

63

East View of Fonthill Abbey, Noon

D 5128

Watercolour on paper 68.5 × 103.5 cm

Provenance: William Beckford, for whom drawn, 1800; ?E. Bertram, sale Christie's March 3 1882 (92), bt. in; Ralph Brocklebank; Duchess of Montrose.

Exhibited: R.A.1800 (663); Brussels 1992.

Literature: Wilton 1979, no.338; Possibly Armstrong 1902, p.254 (as in the possession of R. Brocklebank); Finberg 1961, p.464, no.66 (giving the provenance, incorrectly, as Sir Thomas Barlow and Whitworth Art Gallery, Manchester); Hartley 1984, p.71, cat.68.

Whilst his great 'Abbey' at Fonthill in Wiltshire was still being built, the great eccentric patron and collector William Beckford commissioned Turner to paint seven large watercolours of James Wyatt's brief-lived gothic folly. Turner spent three weeks there in 1799 making drawings ('Fonthill Sketchbook' XLVII and 'Smaller Fonthill Sketchbook' XLVIII, Tate Gallery) for the pictures. Five appear to have been completed, showing the Abbey from different angles and at different times of the day.

A small version of this drawing is now at Leeds (City Art Gallery, cat.13.224/53). There is also a copy of D 5128 at Manchester (Whitworth Art Gallery, reg.D.4.1949).

Accepted by the Inland Revenue in lieu of inheritance tax 1988. On loan to the National Trust for Scotland at Brodick Castle.

64

Caley Hall, Yorkshire with Stag Hunters Returning Home

D 5023.41

Watercolour and gouache on buff paper 30.4 × 42.9 cm

Provenance: Walter Fawkes; by descent to Rev. W. H. Fawkes; Thos. Agnew and Sons., 1938; Sir Thomas Barlow.

Exhibited: Lawrie & Co. 1902, no.84; Thos. Agnew & Sons 1938, (139); York City Art Gallery 1980, (67); Paris 1983, (137).

Literature: Wilton 1979, no.612; Finberg 1912, no.96; Andrews 1979, (cat.46).

Caley Hall was owned by Turner's great patron and friend, Walter Fawkes of Farnley Hall. The artist made many drawings of the house and its surroundings (e.g. 'Farnley Sketchbook' CLIII, Tate Gallery); the rocks of Caley Crags, seen in the distance, provided the foreground to Turner's great canvas *Hannibal Crossing the Alps* exhibited at the Royal Academy in 1812 (now Tate Gallery). The moorland surrounding Caley Hall now forms part of an extensive public park, donated by the Fawkes family, but the house (though listed as of historical and architectural significance) was demolished in 1964. This drawing, showing members of the family returning from a hunt, probably dates from about 1818.

Miss Helen Barlow Bequest 1976

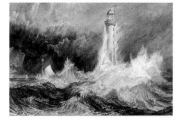

65a

The Bell Rock Lighthouse

D 5181A

Watercolour and gouache with scratching out on paper 30.6 × 45.5 cm
Signed: *JMW Turner RA*

Provenance: Robert Stevenson, for whom drawn 1819; by descent through the family.

Literature: Wilton 1979, no.502; Armstrong 1902, p.242; Finberg 1961, p.257; Gage 1980, nos. 84–5; Irwin and Wilton 1982, p.49; Finlay 1980, pp.28, 248 f.

Engraved: J. Horsburgh 1824, as frontispiece to Robert Stevenson *Account of the Bell Rock Lighthouse*, Edinburgh 1824, (Rawlinson no.201); W. Miller 1862, (Rawlinson no.681).

The drawing records one of the finest achievememts of early nineteenth-century engineering. The Bell Rock light has stood twelve miles off the Firth of Tay for almost one hundred and eighty years. Robert Stevenson's novel design was the forerunner of all subsequent stone lighthouses and the methods which were evolved to construct the tower, between 1807 and 1811, on a partially submerged reef, were revolutionary. Stevenson began his *Account of the Bell Rock Lighthouse* shortly after the project had been completed. In it he describes how he himself had witnessed a spectacular storm around the tower in 1812 'upon which … this work has been delineated'. In 1816 a Scottish drawing-master, Andrew Masson, spent six and a half weeks on the rock recording the seas and their moods and effects. In 1819 James Skene, who had himself drawn

the Light, approached Sir Walter Scott on Stevenson's behalf for an introduction to Turner to produce a watercolour which could be engraved as a frontispiece for the *Account*. Scott (himself a Commissioner of the Northern Lighthouses, with whom Stevenson had visited the rock in 1814) replied that although 'a sketch of the Bell Rock from so masterly a pencil would be indeed a treasure', the artist would 'do nothing without cash and anything for it'.

Turner himself never visited the lighthouse and must have used drawings supplied by Stevenson for the watercolour. He was paid for the drawing by early July 1819 and the *Account* was published in Edinburgh in 1824 with the watercolour engraved by John Horsburgh.

In addition to the letter purchased with the drawing (see D 5181 B, below) it is worth quoting Turner's letter to Stevenson dated July 8 1819 (National Library of Scotland MS. 785 ff.9–10v.) for the light it sheds on the artist's attitude to such commissions. His matter-of-fact tone on the subject of the costs involved was entirely as Scott had predicted:

My Dear Sir

The Drawing of the Bell Light House was sent to the Wharf on Saturday last but the Porter forgot to ask when the Smack (the Swift, according to the paper he brought back) would sail, but I trust by the time you will receive this that she will be near if not at Leith, of which and your approval of my Endeavour I shall be very anxious to hear of, the subject being rather a difficult one, and should you wish or if it requires any alteration do not hesitate to send it up for it, only write the word of the extent, that I may judge how far the same may be beneficial or practicable in a pictorial sense. as to prices, mine are regulated by size, it being somewhat above the thirty Guinea size but not so large as the next one, 35 Gns, the drawing will be therefore 30 Gs, and respecting the Engraving the

plate, Mr Cooke is so much engaged that he has begged he says all further engagements until he can clear off some of his many premiums, indeed, if you wish to have the plate the full size of the drawing, the Expense will be heavy in the line manner. How would the Mezzotinto style suit the object you have in View – and if you wish I can somewhat ascertain the difference before I leave town and send you word. –

If you think of framing my Drawing, do pray not leave so much margin as to the two Drawing[s] sent to me, and let a small flat of matted gold be next the same, thus. May I request if you are passing any time by F. Camerons in Bank St you will favour me by telling him that I received the money and paid the Balance to Mr Palmer and I have his receipt for it.

I am tho in great haste
Yours most respectfully
J.M.W. Turner

Mr Stevenson Baxters Place Edin

Purchased with grants from the National Heritage Memorial Fund and the Pilgrim Trust 1989

65 b

Letter from J. M. W. Turner to Robert Stevenson, dated July 26 1819

D 5181B

Dear Sir

My being from home on Saturday when your favour arrived prevented me then returning you my *thanks* which I beg leave now so to do for the check upon Messrs Barclay and Tritton and remit the receipt according to the request of Mr Kennedy signed as received by

Dear Sir
Yours most truly
J.M.W. Turner

PS. I should very much like to know how you like the drawing. My very short stay in London for I think of leaving for Italy on Saturday, makes it now certain even were you to favour me by return of post, but which I still could wish the chance if convenient to your care [?].

[*Addr.*] Robert Stevenson Esq' Baxters Place Edinburgh or Baxters Square

Purchased with grants from the National Heritage Memorial Fund and the Pilgrim Trust 1989

§5 Drawings attributed to Turner

§6 Drawings formerly attributed to Turner

67

A Timbered House

D 4687

Pencil and grey wash on paper 19.9 × 24.3 cm

D 4687 and D 4802 L are both 'Monro School' drawings which, while not entirely characteristic of the artist, are quite possibly by Turner.

Presented through the National Art Collections Fund 1953, from the Collection of Sir Edward Marsh

68

A Cottage

D 4802 L

Pencil and blue and grey wash on paper 18.3 × 26.5 cm

Provenance unknown

69

Edinburgh from the Water of Leith

D NG 1925

Watercolour on paper 64.1 × 97.1 cm

Provenance: Sir John Fowler; T. F. Blackwell; Christie's June 21 1940 (143);

Literature: Armstrong 1902, p.251

Exhibited: R.A.1889, no.14

This drawing was at one time thought to have been that exhibited under this title at the Royal Academy in 1802 (no.402). In fact the provenance of the drawing cannot be traced back further than the late 1880s. The watercolour is not in good condition and the attribution under which it came into the gallery seems difficult to sustain.

Purchased by the National Art Collections Fund and presented to the Gallery 1940

70

Cottage with Trees

D 3826

Pen and ink on paper 7.5 × 11.2 cm

Charles B. Boog-Watson Gift 1933

71

A Country Inn

D 3827

Pen and ink on paper 7.9 × 12.1 cm

Charles B. Boog-Watson Gift 1933

72

Cottage with Mountains

D 3828

Pen and ink on paper 7.6 × 21.1 cm

Charles B. Boog-Watson Gift 1933

73

View of Durham Cathedral

D 1727

Pencil and wash on paper 20.9 × 32.9 cm

David Laing Bequest to the Royal Scottish Academy transferred 1910

74

An English Cathedral

D 2368

Watercolour on paper 18.7 × 27.3 cm

William Findlay Watson Bequest 1881

75

An English Village Street

D 4784

Sepia and bodycolour on paper 17.4 × 28.1 cm

Mrs Charles de Lemos Gift 1956

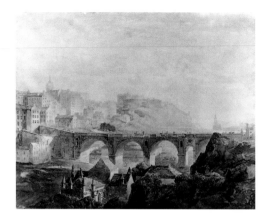

76

Edinburgh from the Calton Hill

D 4802

Watercolour over pencil 49.2 × 62.5 cm
Inscribed: *WM Turner*

Provenance: Thomas Campbell

Exhibited: Edinburgh 1865, cat.156.

In his catalogue to the 1865 exhibition of his own collection, *Edinburgh its Houses and its Noted Inhabitants*, W. F. Watson noted that this drawing had been seen by one of Turner's most noted engravers, William Miller, who had 'pronounced this drawing fine'. The drawing is certainly of great topographical interest and must in any case date from the very early years of the nineteenth century (the Bank of Scotland, absent in this view, was completed in 1805). An attribution to Turner does not however seem to be tenable.

William Findlay Watson Bequest 1881

§7 Prints after Turner

Samuel Middiman, John Pye and Charles Heath
High Street, Oxford
(Rawlinson no.79 I)
Engraving on copper, 1812
Plate size: 50.1 × 65.5 cm; image size: 40.7 × 60.6 cm
This plate is the joint work of three engravers: the open
etching was by Middiman; the burin work, including the
sky, was executed by Pye; the figures by Heath.
Sir Leonard Woolley Gift 1952

William Bernard Cooke (Publisher) 1778–1855
Picturesque Views of the Southern Coast
Two Vols. 1826 (Rawlinson nos.88–127)
Purchased 1955

William Bernard Cooke 1778–1855
Battle Abbey, the Spot where Harold Fell
Illustration for *Views in Sussex*, 1816–1820 Part I, Pl.2,
(Rawlinson no.129 II)
Engraving on copper, 1819
Plate size: 22.5 × 23.6 cm; image size: 16.2 × 24.3 cm
Two parts of *Views in Sussex* were advertised but only one
appeared. This contained the following five line
engravings together with an allegorical design on the
wrapper drawn and etched by Turner (unfortunately this
wrapper is not with the N.G.S. copy of the book). The title
of the work was afterwards changed to *Views in Hastings
and its Vicinity*.
Sir Leonard Woolley Gift 1952

William Bernard Cooke 1778–1855
Brightling Observatory, from Rosehill Park
Illustration for *Views in Sussex*, 1816–1820 Part I, Pl.3,
(Rawlinson no.130 II)
Engraving on copper, 1819
Plate size: 25.3 × 32.8 cm; image size: 19.1 × 28 cm
Sir Leonard Woolley Gift 1952

William Bernard Cooke 1778–1855
The Vale of Ashburnham
Illustration for *Views in Sussex*, 1816–1820 Part I, Pl.4,
(Rawlinson no.131 II)
Engraving on copper, 1819
Plate size: 25.1 × 32.8 cm; image size: 18.7 × 28 cm
Sir Leonard Woolley Gift 1952

William Bernard Cooke 1778–1855
Pevensey Bay from Crowhurst Park
Illustration for *Views in Sussex*, 1816–1820 Part I, Pl.5,
(Rawlinson no.132 II)
Engraving on copper, 1819
Plate size: 25.1 × 32.7 cm; image size: 19 × 28.1 cm
Sir Leonard Woolley Gift 1952

William Bernard Cooke 1778–1855
The Vale of Heathfield
Illustration for *Views in Sussex*, 1816–1820 Part I, Pl.6,
(Rawlinson no.133 II)
Engraving on copper, 1819
Plate size: 25.2 × 32.6 cm; image size: 18.9 × 28.1 cm
Sir Leonard Woolley Gift 1952

William Miller 1796–1882
The Bass Rock
Illustration for Sir Walter Scott, *The Provincial Antiquities
of Scotland*, 1819–1826 Vol.II, p.181
(Rawlinson no.200 Engravers Proof)
Engraving on copper, 1826
Plate size: 31.5 × 44.3 cm; image size: 23.7 × 35.9 cm
Sir Leonard Woolley Gift 1952

John Horsburgh 1791–1869
The Bell Rock Lighthouse
Frontispiece to Robert Stevenson, *Account of the Bell Rock
Lighthouse*, Edinburgh, 1824.
(Rawlinson no.201 I. Two impressions)
Engraving on copper, 1824
Plate size: 22.7 × 29.2 cm; image size: 15 × 22.2 cm
See above for the drawing for this plate, cat.65.
Mr R. Q. C. Stevenson Gift 1990
Sir Leonard Woolley Gift 1952

Edward Goodall 1795–1870
Cologne on the Rhine
(Rawlinson no.203 II)
Engraving on copper, 1824
Plate size: 41.8 × 54.3 cm; image size: 33.4 × 46.8 cm
Sir Leonard Woolley Gift 1952

Edward Goodall 1795–1870
Tivoli. A Composition
(Rawlinson no.207 I)
Engraving on copper, 1827
Plate size: 53.7 × 71.4 cm; image size: 40.3 × 60.5 cm
Sir Leonard Woolley Gift 1952

John Pye 1782–1874
The Temple of Jupiter in the Island of Aegina
(Rawlinson no.208 II. Two impressions)
Engraving on copper, 1828
Plate size: 51.3 × 66.8 cm; image size: 37.8 × 57.5 cm
This work was engraved by John Pye and etched by
S. Middiman.
Sir Leonard Woolley Gift 1952

William Radclyffe c.1783–1855
Ashby de la Zouch, Leicestershire
Illustration for *Picturesque Views in England and Wales*,
1827–1838 part XIV, no.4 (Rawlinson no.264 I)
Engraving on copper, 1832
Plate size: 23.8 × 30.5 cm; image size: 16.8 × 24.2 cm
Sir Leonard Woolley Gift 1952

William Radclyffe c.1783–1855
Blenheim, Oxfordshire
Illustration for *Picturesque Views in England and Wales*,
1827–1838 part XVI, no.2 (Rawlinson no.270 I)
Engraving on copper, 1833
Plate size: 23.8 × 30.7 cm; image size: 15.2 × 24.1 cm
Sir Leonard Woolley Gift 1952

James C. Allen 19th century
Lowestoffe Lighthouse
Vignette Illustration for the so-called *Holloway's
Continuation of 'England and Wales'* (Rawlinson no.305)
Engraving on copper, c.1830
Plate size: 15.8 × 13 cm; image size: 11.5 × 9.5 cm
The so-called *Holloway's Continuation of 'England and
Wales'* consists of three vignettes and five plates (two of
which are absent from our set). The publication for
which the prints were originally made is not certain.
Sir Leonard Woolley Gift 1952

James C. Allen 19th century
Harborough Sands
Vignette Illustration for the so-called *Holloway's
Continuation of 'England and Wales'* (Rawlinson no.306)
Engraving on copper, c.1830
Paper size: 16.8 × 12.9 cm; image size: 12 × 9.4 cm
Sir Leonard Woolley Gift 1952

James C. Allen 19th century
Orford Castle and Church
Vignette Illustration for the so-called *Holloway's
Continuation of 'England and Wales'* (Rawlinson no.307)
Engraving on copper (open etching only), c.1830
Plate size: 31.80 × 22.30 cm; image size: 11.5 × 8 cm
Sir Leonard Woolley Gift 1952

James C. Allen 19th century
Aldborough
Illustration for the so-called *Holloway's Continuation of
'England and Wales'* (Rawlinson no.308)
Engraving on copper, c.1830
Plate size: 22.5 × 31.8 cm; image size: 16.8 × 24.8 cm
Sir Leonard Woolley Gift 1952

James C. Allen 19th century
Dunwich
Illustration for the so-called *Holloway's Continuation of 'England and Wales'* (Rawlinson no.309)
Engraving on copper, *c*.1830
Plate size: 22.5 × 31.8 cm; image size: 17.2 × 25.4 cm
Sir Leonard Woolley Gift 1952

James C. Allen 19th century
Orfordness
Illustration for the so-called *Holloway's Continuation of 'England and Wales'* (Rawlinson no.310)
Engraving on copper, *c*.1830
Plate size: 22.5 × 31.8 cm; image size: 17.8 × 24.9 cm
Sir Leonard Woolley Gift 1952

John Davies 19th century
Mount Blanc
Illustration for *The Bijou*, 1829 (Rawlinson no.313, Published State)
Engraving on steel, 1828
Plate size: 12.9 × 20.3 cm; image size: 7.3 × 9.7 cm
Sir Leonard Woolley Gift 1952

Edward Goodall 1795–1870
Richmond Hill
Illustration for *The Literary Souvenir*, 1826 pl.III, (Rawlinson no.314 Engraver's Proof)
Engraving on steel, 1826
Plate size: 13.8 × 22.8 cm; image size: 6.9 × 11.1 cm
Sir Leonard Woolley Gift 1952

Robert Wallis 1794–1878
Buckfastleigh Abbey, Devonshire
Illustration for *The Literary Souvenir*, 1827 pl.VI (Rawlinson no.316 Engraver's Proof)
Engraving on steel, 1827
Plate size: 13.7 × 19 cm; image size: 7.3 × 10.1 cm
Sir Leonard Woolley Gift 1952

John Pye 1782–1874
Ehrenbreitstein
Illustration for *The Literary Souvenir*, 1829 pl.VIII, (Rawlinson no.317a Engraver's Proof (c))
Engraving on steel, 1828
Plate size: 12.7 × 19.1 cm; image size: 7 × 10.8 cm
Sir Leonard Woolley Gift 1952

Edward Goodall 1795–1870
Florence
Illustration for *The Keepsake*, 1828 (Rawlinson no.319 Engraver's Proof)
Engraving on steel, 1827
Plate size: 14.9 × 21.3 cm; image size: 8.7 × 13 cm

The Keepsake, first published by Charles Heath in 1827, was one of the most successful of the popular literary illustrated 'Annuals' which began to appear in the 1820s. It was a lavish publication which appeared until 1856. Between 1827 and 1837 seventeen plates after Turner appeared in *The Keepsake*.
Sir Leonard Woolley Gift 1952

Robert Wallis 1794–1878
Lake Albano
Illustration for *The Keepsake*, 1829 (Rawlinson no.320 I)
Engraving on steel, 1829
Plate size: 15.1 × 21.5 cm; image size: 9 × 13.3 cm
Sir Leonard Woolley Gift 1952

W. R. Smith fl.1832–1851
Lago Maggiore
Illustration for *The Keepsake*, 1829 (Rawlinson no.321 Engraver's Proof (c); Rawlinson no.321 I. Two impressions)
Engraving on steel, 1829
Plate size: 15.2 × 21.3 cm; image size: 8.7 × 13 cm
Sir Leonard Woolley Gift 1952

Robert Wallis 1794–1878
Virginia Water no.II
Illustration for *The Keepsake*, 1830 (Rawlinson no.323 Engraver's Proof)
Engraving on steel, 1830
Plate size: 15 × 21.3 cm; image size: 9.1 × 13.8 cm
Sir Leonard Woolley Gift 1952

Robert Wallis 1794–1878
Saumur
Illustration for *The Keepsake*, 1831 (Rawlinson no.324 III or later)
Engraving on steel, 1831
Image size: 9.4 × 14 cm (plate mark trimmed)
Sir Leonard Woolley Gift 1952

James Tibbitts Willmore 1800–1864
Nantes
Illustration for *The Keepsake*, 1831 (Rawlinson no.325 Engraver's Proof (d))
Engraving on steel, 1831
Plate size: 15.4 × 21.5 cm; image size: 8.7 × 12.9 cm
Sir Leonard Woolley Gift 1952

Robert Wallis 1794–1878
St Germain-en-Laye
Illustration for *The Keepsake*, 1832 (Rawlinson no.326 I)
Engraving on steel, 1832
Plate size: 15 × 21.5 cm; image size: 9.1 × 14.3 cm
Sir Leonard Woolley Gift 1952

William Miller 1796–1882
Marly
Illustration for *The Keepsake*, 1832 (Rawlinson no.327 Engraver's Proof)
Engraving on steel, 1831
Plate size: 15.1 × 21.4 cm; image size: 9.5 × 14.1 cm
Sir Leonard Woolley Gift 1952

Robert Wallis 1794–1878
Ehrenbreitstein
Illustration for *The Keepsake*, 1833 (Rawlinson no.328 I)
Engraving on steel, 1833
Plate size: 15.1 × 21.4 cm; image size: 9.8 × 14.4 cm
Sir Leonard Woolley Gift 1952

Robert Wallis 1794–1878
Havre
Illustration for *The Keepsake*, 1834 (Rawlinson no.330 Engraver's Proof)
Engraving on steel, 1834
Plate size: 15 × 21.5 cm; image size: 9.8 × 13.9 cm
Sir Leonard Woolley Gift 1952

William Miller 1796–1882
Palace of La Belle Gabrielle
Illustration for *The Keepsake*, 1834 (Rawlinson no.331 I)
Engraving on steel, 1834
Plate size: 15 × 21.4 cm; image size: 9.6 × 13.1 cm
Sir Leonard Woolley Gift 1952

James Tibbitts Willmore 1800–1864
Burning of the Houses of Parliament
Vignette Illustration for *The Keepsake*, 1836 (Rawlinson no.332 Engraver's Proof)
Engraving on steel, 1835
Plate size: 21.7 × 15 cm; image size: 11.5 × 9 cm
Sir Leonard Woolley Gift 1952

James Tibbitts Willmore 1800–1864
Fire at Sea
Vignette Illustration for *The Keepsake*, 1836 (Rawlinson no.333 Engraver's Proof)
Engraving on steel, 1836
Plate size: 21.6 × 15.2 cm; image size: 12.5 × 9 cm
Sir Leonard Woolley Gift 1952

Henry Griffiths d.1849
The Wreck
Vignette Illustration for *The Keepsake*, 1836 (Rawlinson no.334 Engraver's Proof (b))
Engraving on steel, 1836
Plate size: 21.5 × 14.9 cm; image size: 10.5 × 8 cm
Sir Leonard Woolley Gift 1952

James Tibbits Willmore 1800–1864
The Sea! The Sea!
Vignette Illustration for *The Keepsake*, 1837
(Rawlinson no. 335)
Engraving on steel, 1836
Sir Leonard Woolley Gift 1952

Edward Goodall 1795–1870
Florence from the Chiesa al Monte
Illustration for *The Amulet*, 1831 (Rawlinson no.337 I)
Engraving on steel, 1831
Plate size: 14.5 × 21.5 cm; image size: 7.7 × 11.7 cm
Sir Leonard Woolley Gift 1952

T. Crostick 19th century
Fonthill
Illustration for *The Anniversary*, 1829
(Rawlinson no.338 I)
Engraving on steel, 1828
Plate 15.3 × 22.6 cm; image: 8.7 × 12.9 cm
Sir Leonard Woolley Gift 1952

Thomas Jeavons 1816–1867
Vesuvius in Eruption
Illustration for *Friendship's Offering*, 1830
(Rawlinson no.339 Engraver's Proof)
Engraving on steel, 1830
Plate size: 12.5 × 19 cm; image size: 7 × 11 cm
Sir Leonard Woolley Gift 1952

J. Henshall 19th century
The Forum Romanum
Illustration for *The Remembrance*, 1832
(Rawlinson no.340 Engraver's Proof)
Engraving on steel, 1830
Plate size: 12.6 × 19 cm; image size: 7.9 × 12.5 cm
Sir Leonard Woolley Gift 1952

James Tibbitts Willmore 1800–1864
Barnard Castle
Illustration for *The Talisman*, 1831 (Rawlinson no.341
Engraver's Proof (a) and (b). Two impressions)
Engraving on steel, 1831
Plate size: 15.2 × 21.3 cm; image size: 8.6 × 12 cm
Sir Leonard Woolley Gift 1952

Italy by Samuel Rogers
(Rawlinson nos.348–372), 1830
Provenance unknown

W. R. Smith fl.1832–1851
Hospice of the Great St Bernard II (The Dead-House)
Vignette Illustration for Rogers' *Italy*, 1830, p.16.
(Rawlinson no.352 I or later)
Engraving on steel
Image size: 8.5 × 5.3 (plate mark trimmed)
Sir Leonard Woolley Gift 1952

Edward Goodall 1795–1870
Perugia
Vignette Illustration for Rogers' *Italy*, 1830, p.168.
(Rawlinson no.366. Proof touched in pencil)
Engraving on steel, 1830
Plate size: 26.1 × 14.2 cm; image size: 5.9 × 8.4 cm
Sir Leonard Woolley Gift 1952

Robert Wallis 1794–1878
Banditti
Vignette Illustration for Rogers' *Italy*, 1830, p.183.
(Rawlinson no.367 I)
Engraving on steel, 1830
Plate size: 26 × 14 cm; image size: 9.3 × 8.2 cm
Sir Leonard Woolley Gift 1952

Robert Brandard 1805–1862
Rietz, near Saumur
Illustration for *Turner's Annual Tour – The Loire*, 1833
(Rawlinson no.444 II)
Engraving on steel, 1833
Plate size: 15.1 × 22.9 cm; image size: 8.9 × 13.7 cm
Sir Leonard Woolley Gift 1952

James Tibbitts Willmore 1800–1864
Montjen
Illustration for *Turner's Annual Tour – The Loire*, 1833
(Rawlinson no.445 I or later)
Engraving on steel, 1833
Image size: 9.7 × 13.7 cm (plate mark trimmed)
Sir Leonard Woolley Gift 1952

James Baylie Allen 1803–1876
Havre
Illustration for *Turner's Annual Tour – The Seine*, 1834
(Rawlinson no.454 IV or later)
Engraving on steel, 1834
Image size: 9.8 × 13.8 cm (plate mark trimmed)
Sir Leonard Woolley Gift 1952

Robert Brandard 1805–1862
Château de Tancarville, with Town of Quilleboeuf
Illustration for *Turner's Annual Tour – The Seine*, 1834
(Rawlinson no.459 IV or later)
Engraving on steel, 1834
Image size: 9.2 × 13.9 cm (plate mark trimmed)
Sir Leonard Woolley Gift 1952

James Tibbitts Willmore 1800–1864
Lillebonne, Château
Illustration for *Turner's Annual Tour – The Seine*, 1834
(Rawlinson no.461 I)
Engraving on steel, 1834
Image size: 9.4 × 13.7 (plate mark trimmed)
Sir Leonard Woolley Gift 1952

James Charles Armytage 19th century
Jumièges
Illustration for *Turner's Annual Tour – The Seine*, 1834
(Rawlinson no.463 IV or later)
Engraving on steel, 1834
Image size: 10.2 × 14.2 cm (plate mark trimmed)
Sir Leonard Woolley Gift 1952

Edward Goodall 1795–1870
Carlisle
Illustration for *The Minstrelsy of the Scottish Borders*, from
Scott's Poetical Works, 1834. Frontispiece to Vol.I.
(Rawlinson no.493 II)
Engraving on steel, 1833
Plate size: 13.1 × 20.8 cm; image size: 8.3 × 14.2 cm
Sir Leonard Woolley Gift 1952

John Horsburgh 1791–1869
Dryden's Monument
Vignette Illustration for the *Life of Dryden*, from *Scott's
Prose Works*, 1834–1836 (Rawlinson no.517 I)
Engraving on steel, 1834
Plate size: 21 × 15.1 cm
Sir Leonard Woolley Gift 1952

William Miller 1796–1882
Dumbarton Castle
Vignette Illustration for the *Biographical Memoirs*, from
Scott's Prose Works, 1834–1836 (Rawlinson no.518 I)
Engraving on steel, 1834
Plate size: 21.1 × 15.2 cm; image size: 7.9 × 9 cm
Sir Leonard Woolley Gift 1952

William Miller 1796–1882
Brussels – Distant View
Illustration for *Paul's Letters* from *Scott's Prose Works*, 1834–
1836 (Rawlinson no.519 I)
Engraving on steel, 1834–1836
Plate size: 15.2 × 20.8 cm; image size: 8.2 × 13.9 cm
Sir Leonard Woolley Gift 1952

William Miller 1796–1882
New Abbey near Dumfries
Vignette Illustration for *Scott's Prose Works*, Vol.VII, 1834–
1836 (Rawlinson no.521 I. Two impressions)
Engraving on steel, 1834
Plate size: 21 × 15.1 cm; image size: 11.9 × 8.7 cm
Sir Leonard Woolley Gift 1952

Edward Goodall 1795–1870
The Bellerophon, Plymouth Sound
Vignette Illustration for the *Life of Napoleon*, from *Scott's
Prose Works*, 1834–1836 (Rawlinson no.540 Engraver's
Proof)
Engraving on steel, 1835
Plate size: 21 × 15 cm; image size: 11 × 8.3 cm
Sir Leonard Woolley Gift 1952

William Miller 1796–1882
The Rhymer's Glen, Abbotsford
Vignette Illustration for *Periodical Criticism* from *Scott's Prose Works*, 1834–1836 (Rawlinson no.542 I)
Engraving on steel, 1835
Plate size: 21 × 15 cm. See above for the drawing for this plate, cat.12.
Sir Leonard Woolley Gift 1952

John Horsburgh 1791–1869
Dunfermline
Vignette Illustration for *Tales of a Grandfather*, from *Scott's Prose Works*, 1834–1836 (Rawlinson no.544 I)
Engraving on steel, 1836
Plate size: 20.8 × 15 cm; image size: 9.8 × 8.7 cm
Sir Leonard Woolley Gift 1952

William Miller 1796–1882
Craigmillar Castle
Vignette Illustration for *Tales of a Grandfather*, from *Scott's Prose Works*, 1834–1836 (Rawlinson no.546 I)
Engraving on steel, 1836
Plate size: 20.5 × 15.1 cm; image size: 9.5 × 8.1 cm
Sir Leonard Woolley Gift 1952

William Miller 1796–1882
Linlithgow
Vignette Illustration for *Tales of a Grandfather*, from *Scott's Prose Works*, 1834–1836 (Rawlinson no.548 I)
Engraving on steel, 1836
Plate size: 21.2 × 15.1 cm; image size: 8.5 × 8.5 cm
Sir Leonard Woolley Gift 1952

William Miller 1796–1882
Glencoe
Vignette Illustration for *Tales of a Grandfather*, from *Scott's Prose Works*, 1834–1836 (Rawlinson no.549 I)
Engraving on steel, 1836
Plate size: 15 × 21 cm; image size: 8.5 × 14.2 cm
Sir Leonard Woolley Gift 1952

William Miller 1796–1882
Killiecrankie
Vignette Illustration for *Tales of a Grandfather*, from *Scott's Prose Works*, 1834–1836 (Rawlinson no.550 I)
Engaving on steel, 1836
Plate size: 23 × 14.9 cm; image size: 10.5 × 8.4 cm
Sir Leonard Woolley Gift 1952

William Miller 1796–1882
Inverness
Illustration for *Tales of a Grandfather*, from *Scott's Prose Works*, 1834–1836 (Rawlinson no.551 I)
Engraving on steel, 1836
Plate size: 15.2 × 21 cm
Sir Leonard Woolley Gift 1952

William Finden 1787–1852
Col. Mannering, Hazlewood, and Smugglers
Illustration for *Guy Mannering*, from Fisher's *Illustrations to the Waverley Novels*, 1836–1837 (Rawlinson no.561)
Engraving on steel, 1836
Plate size: 12 × 18 cm; image size: 8.2 × 13.4 cm
Sir Leonard Woolley Gift 1952

J. C. Armytage 19th century
'It's Auld Ailie Hersell'
Illustration for the *Black Dwarf*, from Fisher's *Illustrations to the Waverley Novels*, 1836–1837 (Rawlinson no.563 I)
Engraving on steel, 1836
Plate size: 11.9 × 18.1 cm; image size: 8.1 × 13.3 cm
Sir Leonard Woolley Gift 1952

Edward Francis Finden 1791–1857
Mount Moriah
Illustration for Finden's *Landscape Illustrations of the Bible*, Vol.I, 1835–1836 (Rawlinson no.572 Engraver's Proof)
Engraving on steel, 1834
Plate size: 22.6 × 27.7 cm; image size: 9.5 × 13.4 cm
Turner never visited the Holy Land. He based the compositions of his twenty-six drawings for Finden's *Landscape Illustrations* on 'original sketches taken on the spot' by other artists.
Sir Leonard Woolley Gift 1952

Edward Francis Finden 1791–1857
The Red Sea and Suez
Illustration for Finden's *Landscape Illustrations of the Bible*, Vol.I, 1835–1836 (Rawlinson no.573 Engraver's Proof)
Engraving on steel, 1835
Plate size: 17.7 × 25.1 cm; image size: 9.9 × 14.2 cm
Sir Leonard Woolley Gift 1952

James Baylie Allen 1803–1876
Mount Sinai, the valley in which the Children of Israel were encamped
Illustration for Finden's *Landscape Illustrations of the Bible*, Vol.I, 1835–1836 (Rawlinson no.574 Engraver's Proof)
Engraving on steel, 1834
Plate size: 22.7 × 27.7 cm; image size: 8.7 × 14.1 cm
Sir Leonard Woolley Gift 1952

Edward Francis Finden 1791–1857
The Desert of Sinai
Illustration for Finden's *Landscape Illustrations of the Bible*, Vol.I, 1835–1836 (Rawlinson no.575 I)
Engraving on steel, 1834
Plate size: 17.7 × 25.5 cm; image size: 10.2 × 14.3 cm
Sir Leonard Woolley Gift 1952

William Finden 1787–1852
Jericho
Illustration for Finden's *Landscape Illustrations of the Bible*, Vol.I, 1835–1836 (Rawlinson no.576 Engraver's Proof)
Engraving on steel, 1835
Plate size: 17.7 × 25.6 cm; image size: 8.9 × 13.8 cm
Sir Leonard Woolley Gift 1952

Edward Francis Finden 1791–1857
The Dead Sea, Jericho and Mouth of Jordan
Illustration for Finden's *Landscape Illustrations of the Bible*, Vol.I, 1835–1836 (Rawlinson no.577 Engraver's Proof)
Engraving on steel, 1834
Plate size: 22.6 × 27.7 cm; image size: 9.7 × 14 cm
Sir Leonard Woolley Gift 1952

James Baylie Allen 1803–1876
The Wilderness of Engedi and the Convent of Santa Saba
Illustration for Finden's *Landscape Illustrations of the Bible*, Vol.I, 1835–1836 (Rawlinson no.578 Engraver's Proof)
Engraving on steel, 1834
Plate size: 22.7 × 27.9 cm; image size: 10.2 × 14.1 cm
Sir Leonard Woolley Gift 1952

Edward Francis Finden 1791–1857
Joppa
Illustration for Finden's *Landscape Illustrations of the Bible*, Vol.I, 1835–1836 (Rawlinson no.579 Engraver's Proof)
Engraving on steel, 1834
Plate size: 22.6 × 27.7 cm; image size: 9.1 × 14.3 cm
Sir Leonard Woolley Gift 1952

J. Stephenson 19th century
Solomon's Pools
Illustration for Finden's *Landscape Illustrations of the Bible*, Vol.I, 1835–1836 (Rawlinson no.580 Engraver's Proof)
Engraving on steel, 1834
Plate size: 22.7 × 27.8 cm; image size: 9.5 × 14 cm
Sir Leonard Woolley Gift 1952

William Finden 1787–1852
Ramah and Rachel's Tomb
Illustration for Finden's *Landscape Illustrations of the Bible*, Vol.I, 1835–1836 (Rawlinson no.581 Engraver's Proof)
Engraving on steel, 1835
Plate size: 17.7 × 25.3 cm; image size: 9.8 × 14.6 cm
Sir Leonard Woolley Gift 1952

John Cousen 1804–1880
Babylon
Illustration for Finden's *Landscape Illustrations of the Bible*, Vol.I, 1835–1836 (Rawlinson no.582 Engraver's Proof)
Engraving on steel, 1834
Plate size: 22.9 × 27.8 cm; image size: 9.7 × 14.2 cm
Sir Leonard Woolley Gift 1952

Edward Francis Finden 1791–1857
Egypt, The Pyramids of Ghizeh
Illustration for Finden's *Landscape Illustrations of the Bible*,
Vol.I, 1835–1836 (Rawlinson no.583 Engraver's Proof)
Engraving on steel, 1836
Plate size: 17.7 × 25.3 cm; image size: 9.5 × 14.2 cm
Sir Leonard Woolley Gift 1952

William Finden 1787–1852
Mount Lebanon and the Convent of St. Antonio
Illustration for Finden's *Landscape Illustrations of the Bible*,
Vol.I, 1835–1836 (Rawlinson no.584 Engraver's Proof)
Engraving on steel, 1834
Plate size: 22.6 × 27.8 cm; image size: 9.7 × 14 cm
Sir Leonard Woolley Gift 1952

William Radclyffe c. 1783–1855
Nineveh, Moussul on the Tigris
Illustration for Finden's *Landscape Illustrations of the Bible*,
Vol.II, 1835–1836 (Rawlinson no.585 Engraver's Proof)
Engraving on steel, 1835
Plate size: 17.8 × 25.6 cm; image size: 9.6 × 13.9 cm
Sir Leonard Woolley Gift 1952

Edward Francis Finden 1791–1857
Lebanon from Tripoli
Illustration for Finden's *Landscape Illustrations of the Bible*,
Vol.II, 1835–1836 (Rawlinson no.586 Engraver's Proof)
Engraving on steel, 1835
Plate size: 17.5 × 25 cm; image size: 9.5 × 14.1 cm
Sir Leonard Woolley Gift 1952

James Baylie Allen 1803–1876
Jerusalem from the Mount of Olives
Illustration for Finden's *Landscape Illustrations of the Bible*,
Vol.II, 1835–1836 (Rawlinson no.587 Engraver's Proof)
Engraving on steel, 1835
Plate size: 17.2 × 25.1 cm; image size: 9.4 × 14.1 cm
Sir Leonard Woolley Gift 1952

Edward Francis Finden 1791–1857
Bethlehem
Illustration for Finden's *Landscape Illustrations of the Bible*,
Vol.II, 1835–1836 (Rawlinson no.588 Engraver's Proof)
Engraving on steel, 1834
Plate size: 22.5 × 27.7 cm; image size: 9.2 × 14.1 cm
Sir Leonard Woolley Gift 1952

Edward Francis Finden 1791–1857
Nazareth
Illustration for Finden's *Landscape Illustrations of the Bible*,
Vol.II, 1835–1836 (Rawlinson no.589 Engraver's Proof)
Engraving on steel, 1834
Plate size: 22.5 × 27.7 cm; image size: 9.2 × 14.1 cm
Sir Leonard Woolley Gift 1952

William Finden 1787–1852
Jerusalem with the Walls
Illustration for Finden's *Landscape Illustrations of the Bible*,
Vol.II, 1835–1836 (Rawlinson no.590 Engraver's Proof)
Engraving on steel, 1834
Plate size: 22.8 × 28 cm; image size: 9.4 × 14.8 cm
Sir Leonard Woolley Gift 1952

William Finden 1787–1852
Jerusalem, Pool of Bethesda
Illustration for Finden's *Landscape Illustrations of the Bible*,
Vol.II, 1835–1836 (Rawlinson no.591 Engraver's Proof)
Engraving on steel, 1834
Plate size: 22.5 × 27.6 cm; image size: 9.6 × 14.2 cm
Sir Leonard Woolley Gift 1952

Edward Francis Finden 1791–1857
Valley of the Brook Kedron
Illustration for Finden's *Landscape Illustrations of the Bible*,
Vol.II, 1835–1836 (Rawlinson no.592 Engraver's Proof)
Engraving on steel, 1834
Image size: 22.5 × 27.5 cm; image size: 9.2 × 13.4 cm
Sir Leonard Woolley Gift 1952

Edward Francis Finden 1791–1857
Corinth (Cenchrea)
Illustration for Finden's *Landscape Illustrations of the Bible*,
Vol.II, 1835–1836 (Rawlinson no.593 Engraver's Proof)
Engraving on steel, 1834
Plate size: 17.3 × 25.3 cm; image size: 9.6 × 14.2 cm
Sir Leonard Woolley Gift 1952

William Finden 1787–1852
Assos
Illustration for Finden's *Landscape Illustrations of the Bible*,
Vol.II, 1835–1836 (Rawlinson no.594 Engraver's Proof)
Engraving on steel, 1834
Plate size: 22.7 × 27.6 cm; image size: 9.2 × 13.8 cm
Sir Leonard Woolley Gift 1952

Samuel Fisher 19th century
Rhodes
Illustration for Finden's *Landscape Illustrations of the Bible*,
Vol.II, 1835–1836 (Rawlinson no.595 Engraver's Proof)
Engraving on steel, 1835
Plate size: 17.6 × 25.6 cm; image size: 9.4 × 14.3 cm
Sir Leonard Woolley Gift 1952

William Finden 1787–1852
Sidon
Illustration for Finden's *Landscape Illustrations of the Bible*,
Vol.II, 1835–1836 (Rawlinson no.596 Engraver's Proof)
Engraving on steel, 1834
Plate size: 22.5 × 27.8 cm; image size: 9.1 × 13.5 cm
Sir Leonard Woolley Gift 1952

Edward Francis Finden 1791–1857
Jerusalem from the Latin Convent
Unpublished illustration to Finden's *Landscape
Illustrations of the Bible*, 1835–1836 (Rawlinson no.597
Engraver's Proof)
Engraving on steel, 1833
Plate size: 22.5 × 27.8 cm; image size: 9.1 × 13.4 cm
Sir Leonard Woolley Gift 1952

James Baylie Allen 1803–1876
Mussooree and the Dhoon from Landour
Illustration for White's *Views in India*, 1836–1837
(Rawlinson no.607)
Engraving on steel, 1838
Plate size: 22 × 28.9 cm; image size: 12.6 × 20.3 cm
Provenance unknown

W. Floyd 19th century
Valley of the Dhoon, Himalaya Mountains
Illustration for White's *Views in India*, 1836–1837
(Rawlinson no.611)
Engraving on steel, 1838
Plate size: 23.1 × 29.1 cm; image size: 13.7 × 20.2 cm
Provenance unknown

Edward Moxon (Publisher)
Poetical Works of Thomas Campbell
(Rawlinson nos.613–632)
1837
Provenance unknown

William Miller 1796–1882
The Grand Canal, Venice
(Rawlinson no.648 III)
Engraving on copper, 1838
Image size: 37.8 × 58.1 cm (plate mark trimmed)
Provenance unknown

W. R. Smith fl.1832–1851
Dido and Aeneas; The Morning of the Chase
(Rawlinson no.652 I)
Engraving on copper, 1842
Plate size: 53.4 × 70.8 cm; image size: 40.7 cm × 61 cm
Sir Leonard Woolley Gift 1952

Edward Goodall 1795–1870
Caligula's Palace and Bridge
(Rawlinson no.653 III)
Engraving on copper, 1842
Plate size: 54 × 71.4 cm; image size: 39.7 × 61.6 cm
Sir Leonard Woolley Gift 1952

James Tibbitts Willmore 1800–1864
Ancient Italy
(Rawlinson no.657 Engraver's Proof (c))
Engraving on copper, 1842
Plate size: 72 × 51.5 cm; image size: 43.4 × 60.1 cm
Sir Leonard Woolley Gift 1952

William Miller 1796–1882
Modern Italy
(Rawlinson no.658 National Art Union Proof)
Engraving on copper, 1843
Plate size: 53.7 × 70.7 cm; image size: 42.9 × 60.5 cm
Sir Leonard Woolley Gift 1952

James Tibbitts Willmore 1800–1864
Oberwesel
(Rawlinson no.660 IV)
Engraving on steel, 1844
Image size: 22.80 × 34.10 cm (plate mark trimmed)
Sir Leonard Woolley Gift 1952

James Tibbitts Willmore 1800–1864
The Old Téméraire
(Rawlinson no.661)
Engraving on steel, 1845
Plate size: 35.5 × 50.5 cm; image size: 28 × 37.8 cm
Transferred from the Scottish National Portrait Gallery

John Pye 1782–1874
Ehrenbreitstein
(Rawlinson no.662 Engraver's Proof (b))
Engraving on copper, 1845
Plate size: 28 × 38.7 cm; image size: 28.2 × 38.7 cm
Sir Leonard Woolley Gift 1952

Thomas Abiel Prior 1809–1886
Heidelberg from the Opposite Bank of the Neckar
(Rawlinson no.663 I)
Engraving on steel, 1846
Image size: 36.8 × 54 cm (plate mark trimmed)
Transferred from the Scottish National Portrait Gallery

William Miller 1796–1882
Kilchurn Castle, Loch Awe
(Rawlinson no.664 Engraver's Proof and II. Two
impressions)
Engraving on steel, 1847
Plate size: 47.8 × 65.8 cm; image size: 33.7 × 50.9 cm
Sir Leonard Woolley Gift 1952

James Tibbitts Willmore 1800–1864
Dover
(Rawlinson no.666 I. Two impressions)
Engraving on steel, 1851
Plate size: 52.5 × 67.5 cm; image size: 40.7 × 59.6 cm
Sir Leonard Woolley Gift 1952

William Miller 1796–1882
The Rhine, Osterspey and Feltzen
(Rawlinson no.669 II)
Engraving on steel, 1852
Plate size: 30.5 × 40.1 cm; image size: 18.5 × 28.9 cm
Sir Leonard Woolley Gift 1952

Robert Wallis 1794–1878
Lake of Lucerne
(Rawlinson no.671)
Engraving on steel, 1854
Image size: 28.9 × 47.4 cm (plate mark trimmed)
Sir Leonard Woolley Gift 1952

Thomas Abiel Prior 1809–1886
Zurich
(Rawlinson no.672 I)
Engraving on steel, 1854
Plate size: 42 × 58.8 cm; image size: 29.7 × 48.4 cm
Sir Leonard Woolley Gift 1952

James Tibbits Willmore 1800–1864
The Temple of Minerva Sunias, Cape Colonna
(Rawlinson no.673)
Engraving on steel, 1854
Plate size: 52.8 × 67.5 cm; image size: 38.6 × 58.5 cm
This plate bears the inscription that it was engraved
exclusively for the Members of the Association for the
Promotion of Fine Arts in Scotland.
Sir Leonard Woolley Gift 1952

William Miller 1796–1882
Venice – The Piazzetta
(Rawlinson no.674 Engraver's Proof)
Engraving on steel, 1854
Plate size: 43 × 35.5 cm; image size: 29.3 × 24 cm
Sir Leonard Woolley Gift 1952

James Tibbits Willmore 1800–1864
**Venice – Bellini's Pictures Being Conveyed to the Church
of the Redentore**
(Rawlinson no.677a)
Engraving on steel, 1858
Image size: 60.5 × 38.6 cm
Sir Leonard Woolley Gift 1952

John Burnet 1784–1868
Battle of Trafalgar, Nelson's Ship
(Rawlinson no.678 III)
Engraving on steel, 1858
Image size: 55.7 × 81.2
Sir Leonard Woolley Gift 1952

James Tibbitts Willmore 1800–1864
Italy – Childe Harold's Pilgrimage
(Rawlinson no.680 II)
Engraving on steel, 1861
Plate size: 53.2 × 76.5 cm; image size: 40.1 × 66.2 cm
Sir Leonard Woolley Gift 1952

William Miller 1796–1882
The Bell Rock Lighthouse
(Rawlinson no.681 II)
Engraving on steel, 1864
Plate size: 55.5 × 40.3 cm; image size: 45.9 × 31 cm
See above for the drawing for this plate, cat.65.
Mr R. Q. C. Stevenson Gift 1990

William Chapman fl.1863–1875 and Thomas Abiel Prior
1809–1886
The Sun Rising in a Mist
(Rawlinson no.685 I)
Engraving on steel, 1874
Plate size: 52.9 × 65.6 cm; image size: 41.2 × 55.6 cm
Sir Leonard Woolley Gift 1952

James Tibbitts Willmore 1800–1864
Farne Island Shipwreck
(Rawlinson no.688)
Engraving on steel, c. 1860
Plate size: 24.2 × 30.3 cm; image size: 16.4 × 23.4 cm
Sir Leonard Woolley Gift 1952

John Cousen 1804–1880
Calais Pier
Illustration for *The Turner Gallery*, 1859–1875
Rawlinson no.692)
Engraving on steel, 1859
Image size: 17.2 × 24.4 cm (plate mark trimmed)
Sir Leonard Woolley Gift 1952

Thomas Abiel Prior 1809–1886
The Goddess of Discord in the Garden of Hesperides
Illustration for *The Turner Gallery*, 1859–1875
(Rawlinson no.695)
Engraving on steel, 1859
Image size: 18.4 × 26 cm (plate marked trimmed)
Sir Leonard Woolley Gift 1952

Robert Wallis 1794–1878
On the Thames
Illustration for *The Turner Gallery*, 1859–1875
(Rawlinson no.701. Two impressions)
Engraving on steel
Plate size: 26.5 × 35.2 cm; image size: 16.6 × 28 cm
This plate first appeared in the *Art Journal*, 1854 and did
not appear in the *Turner Gallery* until the edition of 1875.
There are impressions of both of these editions in the
collection.
Sir Leonard Woolley Gift 1952

Robert Brandard 1805–1862
A Frosty Morning – Sunrise
Illustration for *The Turner Gallery*, 1859–1875
(Rawlinson no.704)
Engraving on steel, 1859
Image size: 16.9 × 27.1 cm (plate mark trimmed)
Sir Leonard Woolley Gift 1952

James Baylie Allen 1803–1876
The Temple of Jupiter Panhellenius, Aegina
Illustration for *The Turner Gallery*, 1859–1875
(Rawlinson no.709)
Engraving on steel, 1859
Image size: 17.3 × 25.9 cm (plate mark trimmed)
Sir Leonard Woolley Gift 1952

Robert Wallis 1794–1878
Entrance of the Meuse: Orange Merchantman Going to Pieces
Illustration for *The Turner Gallery*, 1859–1875
(Rawlinson no.711)
Engraving on steel, 1859
Image size: 18.1 × 26.1 cm (plate mark trimmed)
Sir Leonard Woolley Gift 1952

Charles Henry Jeens 1827–1879
The Birdcage: Scene from Boccaccio
Illustration for *The Turner Gallery*, 1859–1875
(Rawlinson no.720)
Engraving on steel, 1859
Image size: 25.3 × 18.8 cm (plate mark trimmed)
Provenance unknown

S. Bradshaw fl.1865–1879
Regulus Leaving Carthage
Illustration for *The Turner Gallery*, 1859–1875
(Rawlinson no.723)
Engraving on steel, 1859
Image size: 19 × 26.7 cm (plate mark trimmed)
Sir Leonard Woolley Gift 1952

Robert Brandard 1805–1862
Vessel in Distress off Yarmouth
Illustration for *The Turner Gallery*, 1859–1875
(Rawlinson no.726)
Engraving on steel, 1859
Image size: 18.8 × 25.6 cm (plate mark trimmed)
Sir Leonard Woolley Gift 1952

James Tibbitts Willmore 1800–1864
Italy: Child Harold's Pilgrimage
Illustration for *The Turner Gallery*, 1859–1875
(Rawlinson no.727)
Engraving on steel, 1859
Image size: 16.3 × 26.4 cm (plate mark trimmed)
Sir Leonard Woolley Gift 1952

John Cousen 1804–1880
St. Michael's Mount
Illustration for *The Turner Gallery*, 1859–1875
(Rawlinson no.727a)
Engraving on steel, 1859
Image size: 18.7 × 24.6 cm (plate mark trimmed)
Sir Leonard Woolley Gift 1952

James Tibbitts Willmore 1800–1864
Venice: The Dogana
Illustration for *The Turner Gallery*, 1859–1875
(Rawlinson no.730)
Engraving on steel, 1859
Image size: 16.8 × 25.1 cm (plate mark trimmed)
This plate was taken from the *Vernon Gallery*, 1849 and did not appear in the *Turner Gallery* until the edition of 1875.
Sir Leonard Woolley Gift 1952

Thomas Abiel Prior 1809–1886
The Golden Bough: Lake Avernus
Illustration for *The Turner Gallery*, 1859–1875
(Rawlinson no.731)
Engraving on steel, 1851
Plate size: 26.6 × 34.8 cm; image size: 16.4 × 25.2 cm
This plate was taken from the *Vernon Gallery*, 1851 and did not appear in the *Turner Gallery* until the edition of 1875.
Sir Leonard Woolley Gift 1952

Edward Paxman Brandard 1819–1898
Apollo and Daphne in the Vale of Tempe
Illustration for *The Turner Gallery*, 1859–1875
(Rawlinson no.734)
Engraving on steel, 1859
Image size: 16.2 × 25.9 cm (plate mark trimmed)
Sir Leonard Woolley Gift 1952

S. Bradshaw fl.1865–1870
The Parting of Hero and Leander
Illustration for *The Turner Gallery*, 1859–1875
(Rawlinson no.734a)
Engraving on steel, 1859
Image size: 16.4 × 26.4 cm (plate mark trimmed)
Sir Leonard Woolley Gift 1952

William Miller 1796–1882
Prince of Orange Landing at Torbay
Illustration for *The Turner Gallery*, 1859–1875
(Rawlinson no.739 Artist's Proof I. Two impressions)
Engraving on steel
Plate size: 26.2 × 34.8 cm; image size: 18.3 × 24.8 cm
This plate was taken from the *Vernon Gallery*, 1852, and did not appear in the *Turner Gallery* until the edition of 1875.
Sir Leonard Woolley Gift 1952

Robert Wallis 1794–1878
The Lake of Lucerne
Illustration for *The Turner Gallery*, 1859–1875
(Rawlinson no.749)
Engraving on steel, 1859
Image size: 15.6 × 25 cm (plate mark trimmed)
Sir Leonard Woolley Gift 1952

Robert Brandard 1805–1862
Whalers: the 'Erebus'
Illustration for *The Turner Gallery*, 1859–1875
(Rawlinson no.750)
Engraving on steel, 1859
Image size: 18.9 × 25.7 cm (plate mark trimmed)
Sir Leonard Woolley Gift 1952

Charles Turner 1773–1857
Shields, on the River Tyne
Illustration for *The Rivers of England*, 1823–1827
(Rawlinson no.752 II. Two impressions)
Mezzotint, 1823
Plate size: 19.1 × 25.5 cm; image size: 15.3 × 21.7 cm
The *Rivers of England* (also known as *River Scenery*) was Turner's first published series engraved in mezzotint. Twenty-one plates appeared between 1823 and 1827, of which 16 were after Turner, four after Girtin and one after Collins.
Sir Leonard Woolley Gift 1952

Thomas Goff Lupton 1791–1873
Newcastle-On-Tyne
Illustration for *The Rivers of England*, 1823–1827
(Rawlinson no.753 II)
Mezzotint, 1823
Plate size: 19.4 × 24.9 cm; image size: 15.6 × 21.9 cm
Sir Leonard Woolley Gift 1952

Charles Turner 1773–1857
More Park, near Watford, on the River Colne
Illustration for *River Scenery*, 1827
(Rawlinson no.754 II or later. Two impressions)
Mezzotint, 1824
Image size: 15.5 × 22.1 cm (plate mark trimmed)
Sir Leonard Woolley Gift 1952

Thomas Goff Lupton 1719–1873
Rochester, on the River Medway
Illustration for *River Scenery*, 1827
(Rawlinson no.755 II or later)
Mezzotint, 1824
Image size: 15.3 × 21.7 cm (plate mark trimmed)
Sir Leonard Woolley Gift 1952

Charles Turner 1773–1857
Norham Castle, on the River Tweed
Illustration for *River Scenery*, 1827
(Rawlinson no.756 II or later)
Mezzotint, 1824
Image size: 15.3 × 21.6 cm (plate mark trimmed)
Sir Leonard Woolley Gift 1952

Thomas Goff Lupton 1719–1873
Dartmouth Castle, on the River Dart
Illustration for *River Scenery*, 1827
(Rawlinson no.757 II or later)
Mezzotint, 1824
Image size: 16 × 22.6 cm (plate mark trimmed)
Sir Leonard Woolley Gift 1952

Charles Turner 1773–1857
Okehampton Castle, on the River Okement
Illustration for *River Scenery*, 1827
(Rawlinson no.758 II or later)
Mezzotint, 1825
Image size: 15.2 × 22.8 cm (plate mark trimmed)
Sir Leonard Woolley Gift 1952

Samuel William Reynolds 1794–1872
Dartmouth, on the River Dart
Illustration for *River Scenery*, 1827
(Rawlinson no.759 II or later)
Mezzotint, 1825
Image size: 15.5 × 22.1 cm (plate mark trimmed)
Sir Leonard Woolley Gift 1952

William Say 1768–1834
Brougham Castle, near the Junction of the Rivers Eamont and Lowther
Illustration for *River Scenery*, 1827
(Rawlinson no.760 II or later)
Mezzotint, 1825
Image size: 15.4 × 21.5 cm (plate mark trimmed)
Sir Leonard Woolley Gift 1952

John Charles Bromley 1795–1839
Kirkstall Abbey, on the River Aire
Illustration for *River Scenery*, 1827
(Rawlinson no.761 II or later)
Mezzotint, 1826
Image size: 16.2 × 22.5 cm (plate mark trimmed)
Sir Leonard Woolley Gift 1952

Thomas Goff Lupton 1719–1873
Warkworth Castle, on the River Coquet
Illustration for *River Scenery*, 1827
(Rawlinson no.762 II or later)
Mezzotint, 1826
Image size: 15 × 21.2 cm (plate mark trimmed)
Sir Leonard Woolley Gift 1952

George Henry Phillips fl.1819–1852
Mouth of the River Humber
Illustration for *River Scenery*, 1827
(Rawlinson no.763 III. Two impressions)
Mezzotint, 1826
Plate size: 19.6 × 25.4 cm; image size: 15.4 × 22.9 cm
Sir Leonard Woolley Gift 1952

George Henry Phillips fl.1819–1852
Arundel Castle, on the River Arun
Illustration for *River Scenery*, 1827
(Rawlinson no.764 II or later)
Mezzotint, 1827
Image size: 15.3 × 22 cm (plate mark trimmed)
Sir Leonard Woolley Gift 1952

William Say 1768–1834
Kirkstall Lock, on the River Aire
Illustration for *River Scenery*, 1827
(Rawlinson no.765 III. Two impressions)
Mezzotint, 1827
Plate size: 19.6 × 25.4 cm; image size: 15.4 × 22.9 cm
Sir Leonard Woolley Gift 1952

Thomas Goff Lupton 1719–1873
Stangate Creek, on the River Medway
Illustration for *River Scenery*, 1827
(Rawlinson no.766 II or later)
Mezzotint, 1827
Image Size: 16.1 × 23.9 cm (plate mark trimmed)
Sir Leonard Woolley Gift 1952

Charles Turner 1773–1857
Totnes, on the Dart
Illustration for *River Scenery*, 1827
(Rawlinson no.767 II)
Mezzotint, 1825
Plate size: 18.8 × 25 cm; image size: 16 × 22.7 cm
Sir Leonard Woolley Gift 1952

Thomas Goff Lupton 1791–1873
The Eddystone Lighthouse
Illustration for *Marine Views*, 1824–1825
(Rawlinson no.771 III)
Mezzotint, 1824
Plate size: 26.5 × 35.8 cm; image size: 21.1 × 31.3 cm
Marine Views was originally intended as a series of larger mezzotints on steel to be issued as single plates, however, only two plates were completed.
Sir Leonard Woolley Gift 1952

John P. Quilley fl.1823–1842
The Deluge
(Rawlinson no.794 I)
Mezzotint, 1828
Plate size: 45.6 × 62.8 cm; image size: 38.2 × 57.6 cm
Sir Leonard Woolley Gift 1952

Frederick Christian Lewis 1779–1856
Field of Waterloo
(Rawlinson no.795 Engraver's Proof (c))
Mezzotint, 1830
Plate size: 46.3 × 64.6 cm; image size: 35.4 × 58.5 cm
Sir Leonard Woolley Gift 1952

W. Davison
Fishing Boats off Calais or 'The Pas de Calais'
(Rawlinson no.796 II)
Mezzotint, 1830
Plate size: 47.1 × 64.2 cm; image size: 39.2 × 58.7 cm
Sir Leonard Woolley Gift 1952

Thomas Goff Lupton 1791–1873
Folkestone
(Rawlinson no.798)
Mezzotint, 1830
Plate size: 26.8 × 35.4 cm; image size: 21 × 30.8 cm
This plate remained unfinished in Lupton's hands until his death. In 1879 it was published by the Fine Art Society.
Sir Leonard Woolley Gift 1952

Thomas Abiel Prior 1809–1886
Venice
(Not in Rawlinson. Two impressions)
Steel engraving
Plate size: 26.7 × 35.5 cm; image size: 15.7 × 24.9 cm
Sir Leonard Woolley Gift 1952

Unknown 19th century
Storm Coming On off Portsmouth
(Not in Rawlinson)
Mezzotint
Plate size: 22.6 × 27.9 cm; image size: 14.7 × 20 cm
Sir Leonard Woolley Gift 1952

Agnew's 1913 Thomas Agnew and Sons, *Exhibition of Watercolour Drawings by J. M. W. Turner, R.A.*, 1913

Agnew's 1967 Thomas Agnew and Sons, *Loan Exhibition of Paintings and Watercolours by J. M. W. Turner, R.A.*, 1967

Andrews 1979 K. Andrews, *English Watercolours and Drawings: The Helen Barlow Bequest*, Edinburgh, 1979

Armstrong 1902 Sir W. Armstrong, *Turner R.A.*, London, 1902

Beattie 1849 W. Beattie, *The Life and Letters of Thomas Campbell*, London, 1849

Bell 1901 C. F. Bell, *The Exhibited Works of J. M. W. Turner*, London, 1901

Bower 1990 P. Bower, *Turner's Papers*, London, 1990

Boase 1956 T. S. R. Boase, 'English Artists in the Val d'Aosta', *Journal of the Warburg and Courtauld Institutes*, XIX, 1956, pp.283–93

Brown 1992 D. B. Brown, *Turner and Byron*, London, 1992

Butlin & Joll 1977 M. Butlin and E. Joll, *The Paintings of J. M. W. Turner*, New Haven and London, 1977

Brussels 1992 Banque Bruxelles Lambert, *The Beckford and Hamilton Silver Collections from Brodick Castle*, 1992

Campbell 1988 R. M. M. Campbell, *Turner's Illustrations to the Poetical Works of Thomas Campbell*, Edinburgh, 1988

Clifford 1982 T. Clifford, *Turner at Manchester; Catalogue Raisonne, Collections of the City Art Gallery*, Manchester, 1982

Cook & Wedderburn 1903–12 E. T. Cooke and A. Wedderburn, *The Works of John Ruskin*, 1903–12

Cooke Gallery 1823 W. B. Cooke Gallery, *Drawings by English Artists*, London, 1823

Cormack 1975 M. Cormack, *J. M. W. Turner, R.A., 1775–1851. A Catalogue of Drawings and Watercolours in the Fitzwilliam Museum, Cambridge*, 1975

Cundall 1916 E. G. Cundall, 'Turner Drawings of Fonthill Abbey' in *Burlington Magazine*, XXIX, 1916, pp.16–21

Dawson 1988 B. Dawson, *Turner in the National Gallery of Ireland*, Dublin, 1988

Dick 1980 J. Dick, *The Vaughan Bequest of Turner Watercolours*, Edinburgh, 1980

Edinburgh 1865 *Edinburgh its Houses and its Noted Inhabitants*, an exhibition of the collection of W. F. Watson, Edinburgh, 1865

Farington K. Garlick, A. Macintyre, ed., *The Farington Diary 1793–1821*, New Haven and London, 1978 et seq.

Finberg 1909 A. J. Finberg, *A complete Inventory of the Drawings of the Turner Bequest*, 2 vols., London, 1909

Finberg 1961 A. J. Finberg, *The Life of J. M. W. Turner R.A.*, Oxford, 1939, 2nd ed., rev. H. F. Finberg, 1961

Finley 1972 G. Finley, 'J. M. W. Turner and Sir Walter Scott: Iconography of a Tour' in *Journal of the Warburg and Courtauld Institutes*, XXXV, 1972, pp.359–85.

Finley 1980 G. Finley, *Landscape of Memory; Turner as Illustrator to Scott*, 1980

Franco-British Exhibition 1908 Fine Art Palace, Shepherd's Bush London, *Franco-British Exhibition, British Section, Pictures by Deceased Artists*, 1908

Gage 1980 J. Gage, *Collected Correspondence of J. M. W. Turner*, Oxford, 1980

Gage 1987 J. Gage, *J. M. W. Turner 'A Wonderful Range of Mind'*, Yale, 1987

Goodall 1902 F. Goodall, *Reminiscences of Frederick Goodall, R.A.*, London and Newcastle, 1902

Guildhall 1899 Guildhall Art Gallery, London, *Loan Collection of Pictures and Drawings by J. M. W. Turner, R.A.*, 1899

Hamburg 1976 Kunsthalle, Hamburg, *William Turner und die Landschaft seiner Zeit (Kunst um 1800)*, 1976

Hartley 1984 C. Hartley, *Turner Watercolours in the Whitworth Art Gallery*, Manchester, 1984

Herrmann 1968 L. Herrmann, *Ruskin and Turner*, London, 1968

Herrmann 1970 L. Herrmann, 'Ruskin and Turner : A Riddle Resolved', *Burlington Magazine*, CXII, 1970, p.696

Herrmann 1990 L. Herrmann, *Turner Prints: The Engraved Work of J. M. W. Turner*, Oxford, 1990

Irwin and Wilton 1982 F. Irwin and A. Wilton, *Turner in Scotland*, Aberdeen, 1982

Lawrie & Co. 1902 Messrs. Lawrie & Co., London, *The Farnley Hall Collection of Pictures and Drawings by J. M. W. Turner R.A.*, 1902

Lindsay 1966 J. Lindsay, *J. M. W. Turner, His Life and Work*, London, 1966

Lyles 1989 A. Lyles, *Young Turner; Early Work to 1800*, London, 1989

Lyles 1992 A. Lyles, *Turner; The Fifth Decade*, London, 1992

Lyles and Perkins 1989 A. Lyles and D. Perkins, *Colour into Line: Turner and the Art of Engraving*, London, 1989

Manchester 1857 Exhibition, *Art Treasures of the United Kingdom Collected at Manchester in 1857*

Moon, Boys and Graves 1833 Moon, Boys and Graves, London, *A Private Exhibition of Drawings by J. M. W. Turner R.A.*, 1833

Munich 1978 Bayerische Staatsgemäldesammlungen, Munich, *Turner und die Dichtkunst*, 1976

Paris 1983 Grand Palais, Paris, *J. M. W. Turner*, 1983–4

Powell 1987 C. Powell, *Turner in the South: Rome, Naples, Florence*, New Haven and London, 1987

Powell 1991 C. Powell, *Turner's Rivers of Europe: The Rhine, Meuse and Mosel*, London, 1991

R.A. 1886 Royal Academy, London, *Old Masters*, 1886

R.A. 1887 Royal Academy, London, *Old Masters*, 1887

R.A. 1892 Royal Academy, London, *Old Masters*, 1892

R.A. 1834 Royal Academy, London, *Exhibition of British Art c.1000–1860*, 1934

R.A. 1974–5 Royal Academy, London, *Turner, 1775–1851*, 1974–5

Rawlinson 1908 W. G. Rawlinson, *The Engraved Work of J. M. W. Turner, R.A.*, London, 1908–13

Russell and Wilton 1976 J. Russell and A. Wilton, *Turner in Switzerland*, Zurich, 1976

Shanes 1979 E. Shanes, *Turner's Picturesque Views in England and Wales 1825–1838*, London, 1979

Stainton 1985 L. Stainton, *Turner's Venice*, London, 1985

Stevenson 1824 R. Stevenson, *Account of the Bell Rock Lighthouse*, Edinburgh, 1824

Tate Gallery 1931 Tate Gallery, London, *Turner's Early Oil Paintings (1796–1815)*, 1931

Thornbury 1862 W. Thornbury, *The Life of J. M. W. Turner, R.A.*, 1862 revised ed., London, 1877

Upstone 1989 *Turner: The Second Decade*, London, 1989

Warrell 1991 *Turner: The Fourth Decade*, London, 1991

Wilton 1975 A. Wilton, *Turner in the British Museum, Drawings and Watercolours*, London, 1975

Wilton 1979 A. Wilton, *J. M. W. Turner His Life and Art*, New York, 1979

Wilton 1980 A. Wilton, *Turner and the Sublime*, London, 1980

Wilton 1982 A. Wilton, *Turner Abroad; France, Italy, Germany, Switzerland*, London, 1982

York 1980 York City Art Gallery, *Turner in Yorkshire*, 1980